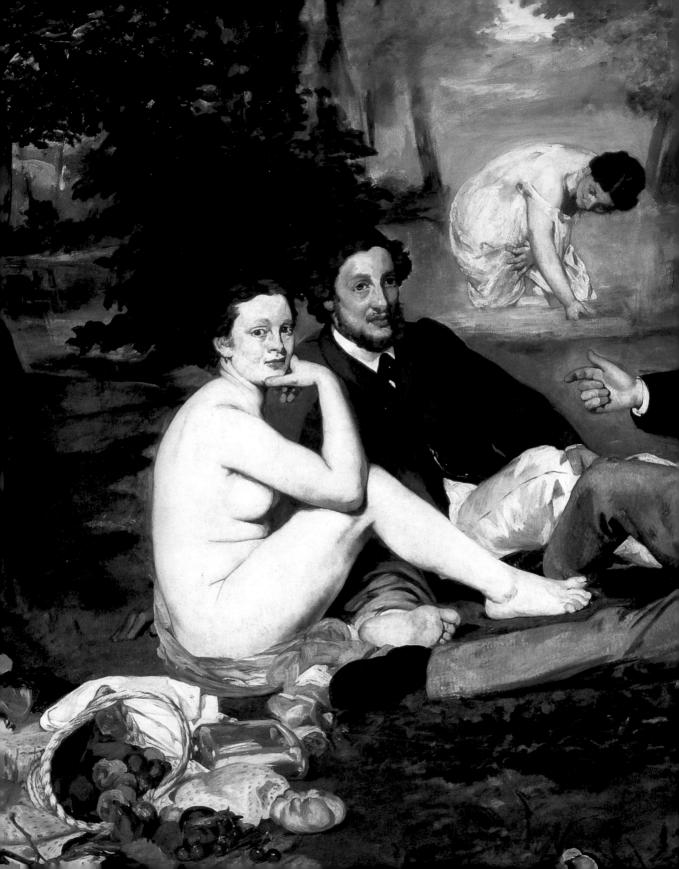

Gilles Néret

ÉDOUARD MANET

1832–1883

The First of the Moderns

TASCHEN

KÖLN LONDON LOS ANGELES MADRID PARIS TOKYO

COVER:
The Balcony (detail of page 46), 1868–1869
Oil on canvas, 169 x 125 cm
Paris, Musée d'Orsay
Photo: RMN, Paris, H. Lewandowski

ILLUSTRATION PAGE 1:
Édouard Manet, c. 1860
Anonymous photograph

ILLUSTRATION PAGE 2:
Le Déjeuner sur l'herbe (detail of page 24/25), 1863
Oil on canvas, 208 x 264 cm
Paris, Musée d'Orsay

BELOW:
Berthe Morisot in Silhouette, 1872–1874
Lithograph
Paris, Bibliothèque Nationale,
Cabinet des Estampes

BACKCOVER:
Édouard Manet, c. 1865
Photograph by Nadar
Paris, Bibliothèque Nationale

© 2003 Taschen GmbH
Hohenzollernring 53, D–50672 Köln
www.taschen.com
Editing and images: Ines Dickmann, Cologne;
Béa Rehders, Paris
Editorial coordination: Kathrin Murr, Cologne
Translation: Chris Miller, Oxford
Cover: Angelika Taschen, Cologne

Printed in Germany
ISBN 3-8228-1949-2

Contents

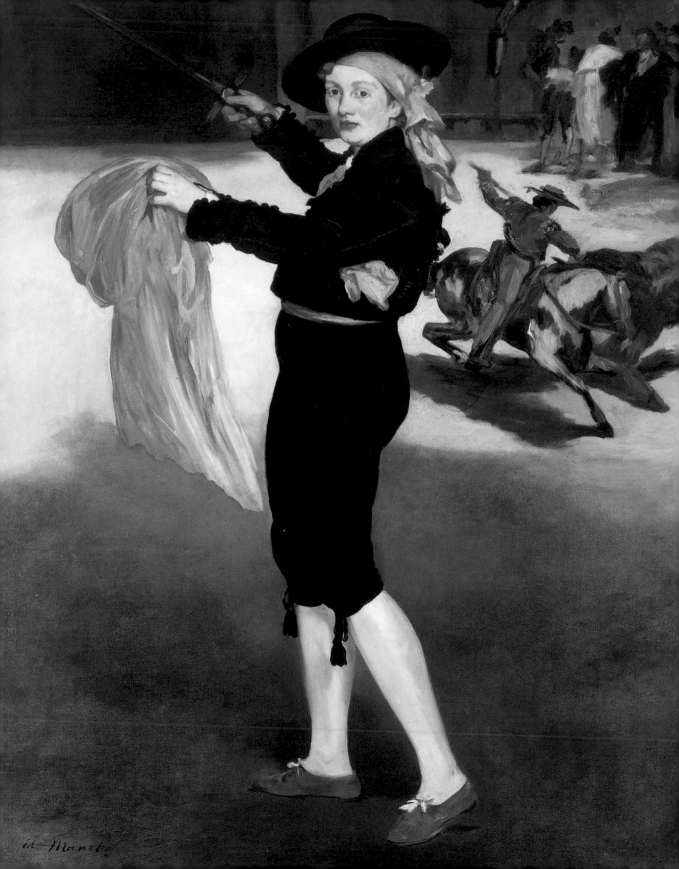

A Wolf in the Spanish Sheepfold
1859–1862

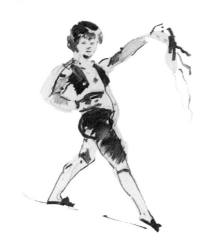

The role played by certain artists in the history of art can seem disproportionate, and disappointment follows. All that fuss about *this*? From Cubism to Malevich's Suprematist icon, *Black Square on a White Background*, countless artistic movements were born of Cézanne's corpus, but Cézanne himself was once described as a "mediocre painter of apples". Manet is just such an artist. He is not one of the greatest painters, but, like Giorgione and Caravaggio, he marks a turning point in the history of art: with him, one world ended and another began. Degas, the most intelligent painter of Manet's time, understood this, observing, as he left the little cemetery in Passy where Manet had been laid to rest, "He was greater than we thought". For the great adventure of modern painting, freed of anecdote and false conventions, begins with Manet. Matisse said of him: "He was the first to act on reflex and thus simplify the painter's business … expressing only what directly touched his senses". The pretext mattered less than the painting. Indeed, a century later, Manet might have been a non-figurative painter; unlike Rembrandt and Delacroix, he rejected psychology, and had no time for secrets of the heart or soul. He was criticised, says Hippolyte Babou, "for seeing the external world only in swathes or dashes of colour, as though he were permanently dazzled".

Manet learnt from bitter experience that the pioneer's burden is a heavy one. It was a paradoxical experience. No revolutionary he; a scion of the bourgeoisie, he stood out among the penniless, rapscallion art students as rich and well-bred. A sociable man, with the elegance of a dandy and the snobbism of a socialite, he was, moreover, an admirer of tradition, and full of respect for the past. He wanted nothing better than to be loved by public and critics alike. He sought official glory and the *imprimatur* of the Salon. Yet, to his dismay, he found himself cast as a ring-leader: chosen against his will as the standard-bearer of Impressionism, decried as heading the "school of the ignoble", he was vilified as a sort of Communard of painting. When Napoleon III married a Spanish bride, the resulting wave of *espagnolisme* found in Manet a willing adept. This was the fashion, and Manet wanted to be a man of his time. No such luck. Despite his best efforts, his painting gave rise to successive scandals. He was, quite simply, ahead of his time. This was the era over which the bourgeois presided unchecked, and they were, by definition, against anything new; they hated what they could not understand. They feared nothing so much as being gulled. In *À Rebours*, Huysmans tells us: "Reassured, the bourgeoisie merrily reigned, wielding the power of its wealth

The Spanish Singer (The Guitarrero), c. 1860
Oil on canvas, 147.3 x 114.3 cm
New York, The Metropolitan Museum of Art,
Gift of William Church Osborn

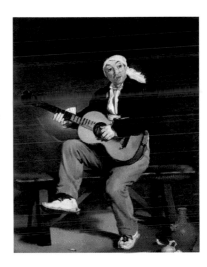

AT THE TOP:
Young Woman in Toreador's Costume, c. 1862
Indian ink wash, 18.4 x 14.5 cm
Private collection

PAGE 6
Mademoiselle V… in the Costume of an Espada, 1862
Oil on canvas, 165.1 x 127.6 cm
New York, The Metropolitan Museum of Art,
H. O. Havemeyer Collection, Bequest of
Mrs. H. O. Havemeyer

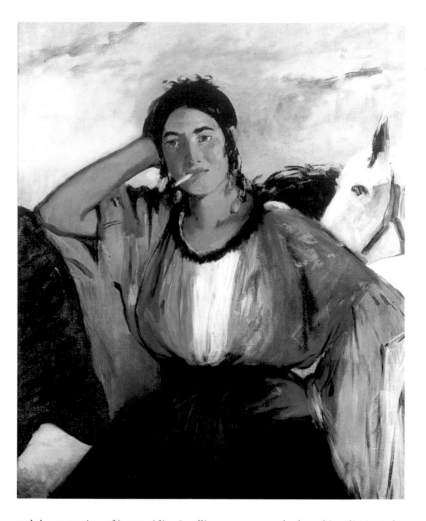

and the contagion of its stupidity. Intelligence was squashed, probity eliminated and art suffocated by its advent." In the form of Salon jury and State, it was, says Zola, "the Maecenas of the day"; there was no other patronage. Its ideal was that of Jarry's *Ubu Roi*: "Chitterling sausage every day, and a carriage for swank". Its pompous asininity was incarnated in Monnier's caricature, Prudhomme. Faced with such blustering, Manet was almost apologetic: "The effect imparted to a work by sincerity may be akin to protest, whereas the painter intended merely to convey an impression, seeking merely to be himself and no one else". "Convey an impression": who else could be the leading light of Impressionism? The enmity Manet incurred in breaking with "high art" traditions and rules cemented his followers' loyalty.

The official taste of the time was spooned from the wells of the Italian Renaissance and Classical Antiquity, while the sordid spectacle of contemporary life was anathema. Manet, for all that he borrowed from Velázquez, Titian and Goya, broke new ground in representation and technique. Those who condemned him as "barbarian", "renegade" and "unpatriotic" were blind to the paradox of his art, in which innovation combines with imitation. Denouncing the *Déjeuner sur l'herbe* (pp. 2 and 24/25), the critics were disconcerted to find its

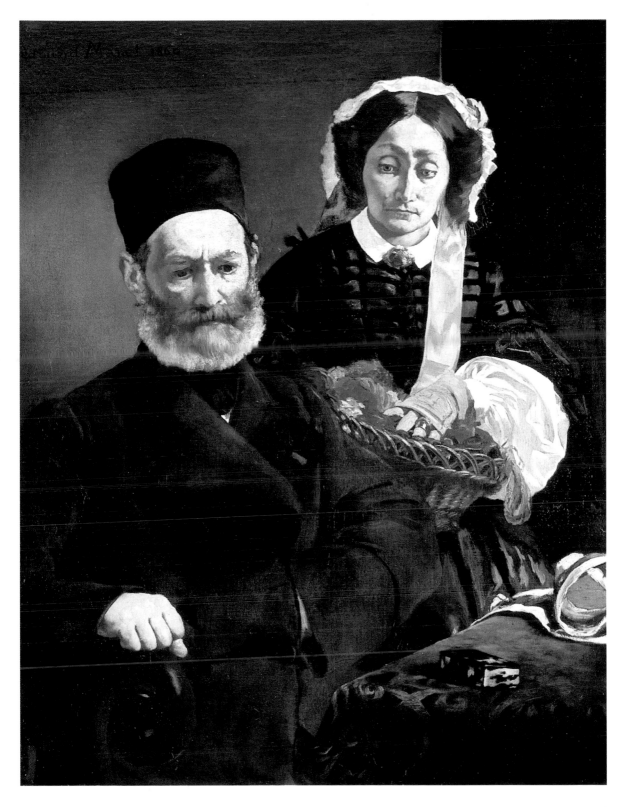

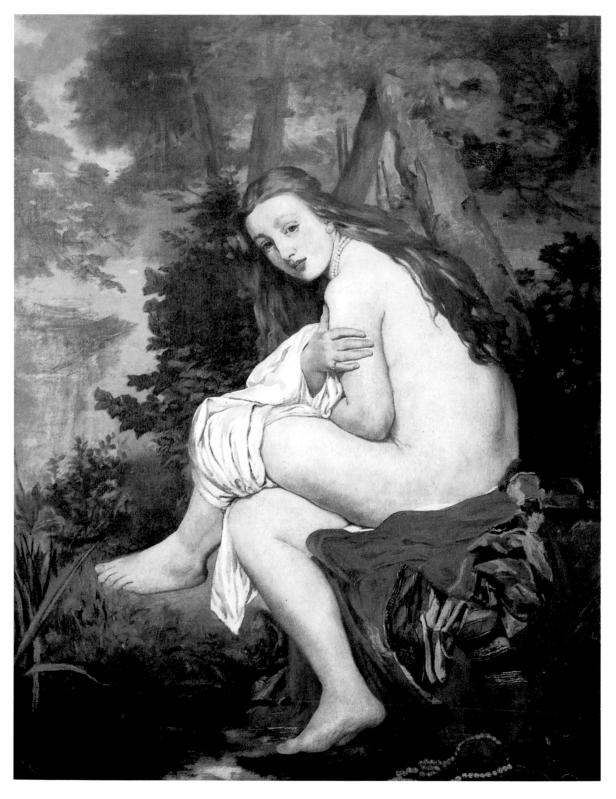

composition copied from a 16th-century print made after Raphael's *Judgment of Paris*, or to discover that Manet's avowed aim was a modern version of Titian's *Concert champêtre* (p. 25). Manet's first stylistic innovation came in *Spanish Singer* (p. 7): the traditional *chiaroscuro* and the half-tones beloved of Delacroix were eliminated in favour of bold contrasts. "No fading in the flower of *his* palette", Jacques-Émile Blanche observed. Manet was the first, in *Music at the Tuileries* (pp. 18/19), to record the unprecedented spectacle of his city and times, the poetry of modern life. Here was the "modernity" demanded by his friend Baudelaire. "Indecent" was the battle-cry, but the establishment's resentment had its source elsewhere; Manet had discovered the juxtaposition of dashes of colour, and in doing so eliminated the transitional tones of classical painting. This was truly unforgivable. The Impressionists were quick to learn from it, Renoir developing the technique in his *Moulin de la Galette* and Monet attempting to go beyond it in *Women in the Garden*. Baudelaire had dreamed of the "true painter" who would be able to "latch onto the epic character of contemporary life and comprehend how great and poetic we are in our cravats and patent-leather boots". But for Manet this view of the bourgeoisie at their rites possessed no other interest than the tonal and formal effects elicited by confronting cylinders of top hat with corollas of hooded cloak and crinoline.

Olympia (pp. 20–23) is today one of the glories of the Musée d'Orsay: an austere nude, devoid of artifice, eloquent and humane in its very plainness. But its forthright realism came as a shock to a public educated on the flirtatious curves of the 18th century. "Manet has made his mark on public opinion", Champfleury told Baudelaire. Paul de Saint-Victor noted "The crowd throngs around Monsieur Manet's gamy *Olympia* like onlookers at a morgue"; others described Manet as a "brute who paints green women with washing-up brushes". In his *The Races at Longchamp* (p. 37), Manet turned aside from urban truth to investigate the representation of speed. Flecks of swirling colour advance through the light, and the gaudy spectacle is captured with photographic instantaneousness. When Manet, speaking of *Déjeuner sur l'herbe* (pp. 2 and 24/25), cited the "transparent atmosphere" in which he wished to set his nude, the expression was completely new to the language of painting. True, the integration of the studio-painted figures into a landscape painted *in situ* leaves something to be desired. But the painting paved the way for the *pleinairisme* of Monet and his friends: for their cult of liberty, worship of the natural, modernity of theme, and bright, forthright, instantaneous vision. In *The Fifer* (p. 32), Manet contrived a bold synthesis of Spanish painting and Japanese prints. The unprecedented conception of space that resulted had a profound impact on Degas, Toulouse-Lautrec, and Gauguin, and subsequently on Matisse, Rouault and the Fauves. Its layered areas of flat colour exasperated Courbet, who remarked "a painting isn't a playing card", to which Manet replied "Yes, yes, we all know Courbet's ideal is a billiard ball!" Manet summarised his aesthetic in a maxim that was to leave its mark on subsequent generations of painters: "Look for grand light and grand shadow, the rest will come of itself, and often doesn't amount to much anyway" – though the little it amounted to weighs heavy in the annals of modern painting.

"Art is a circle," Manet said, "it's matter of chance whether you're born inside or out." But he himself was born on 23 January 1852, at 5 rue Bonaparte (then rue des Petits-Augustins) to a magistrate and a diplomat's daughter, in short, to the well-off *grande bourgeoisie*. An artistic career was not on the agenda. Manet could trace his ancestry over 200 years in the Île-de-France, and not a few of his ancestors were lawyers. Certainly, the young Manet had no thought of the Salon.

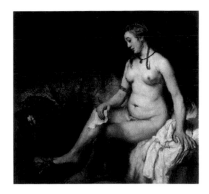

Rembrandt: *Bathsheba*, 1654
Oil on canvas, 142 x 142 cm
Paris, Musée du Louvre

François Boucher: *Diana at Her Bath* (detail), 1742
Oil on canvas, 56.8 x 72.9 cm
Paris, Musée du Louvre

PAGE 10:
The Surprised Nymph, 1859–1861
Oil on canvas, 146 x 114 cm
Buenos Aires, Museo Nacional de Bellas Artes

Baudelaire's Mistress Reclining, 1862
Oil on canvas, 90 x 113 cm
Budapest, Szépmüvészeti Museum

He showed little aptitude for study, and, as a Merchant Navy apprentice, sailed to Rio de Janeiro and back before failing his entrance to the École navale. He and his brother Eugène both took piano lessons with a young Dutchwoman called Suzanne Leenhoff, whom Édouard eventually married. Handsome, charming, frivolous, even a little superficial, he preferred the company of pretty women to aesthetic debate. Only the insistence of his friend Antonin Proust (no relative to the author of *À la recherche*) convinced Manet to join him in Thomas Couture's studio. There, for all his insubordination, he spent six long years. Théodore de Banville described him thus: "Blond Manet with his ready laugh/Seemed grace personified,/Sharp, charming man, to boot/Beneath his Grecian beard/A gentleman from head to foot/But somewhat deified". In short, the man-about-town concealed the artist, who never sought to be anyone's *Cher Maître*. Fantin-Latour's description is confirmed by a contemporary photo: "The man to whom the bourgeoisie affixes the features of a wild art-student is an all but irreproachable *boulevardier*. This revolutionary of painting is a veritable slave to fashion: a Marat-Brummel." A dandy he may have been, but the greatest minds of his time were glad to be counted among his friends: Baudelaire, Zola and Mallarmé.

Couture was a fashionable *peintre-pompier*, and his prices – and sales – were high enough to reassure Manet's parents; his most famous productions are

LEFT:
Baudelaire, with Hat, in Profile, 1867–1868
Etching, second plate, 10.9 x 9 cm
Paris, Bibliothèque Nationale,
Cabinet des Estampes

RIGHT:
Baudelaire Bareheaded, Full Face,
1865–1868 (?)
Etching (2nd state), 10.2 x 8.4 cm
Paris, Bibliothèque Nationale,
Cabinet des Estampes

BELOW:
Young Woman Reclining, in Spanish Costume,
1862
Oil on canvas, 94 x 113 cm
New Haven (CT), Yale University Art Gallery,
Bequest of Stephen Carlton Clark

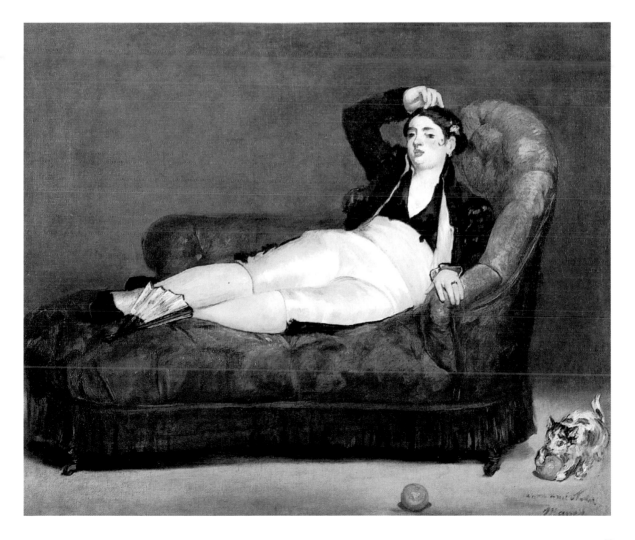

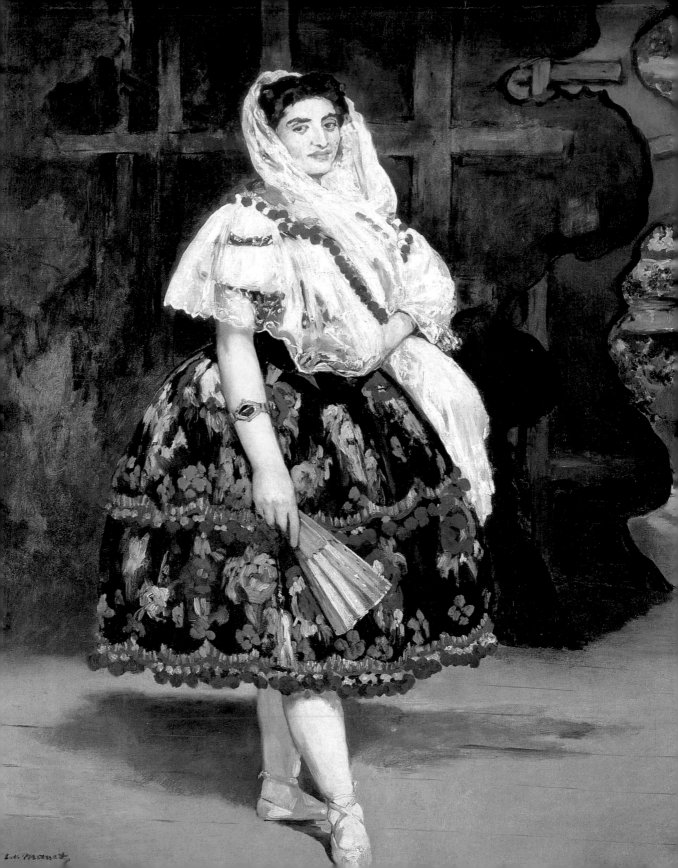

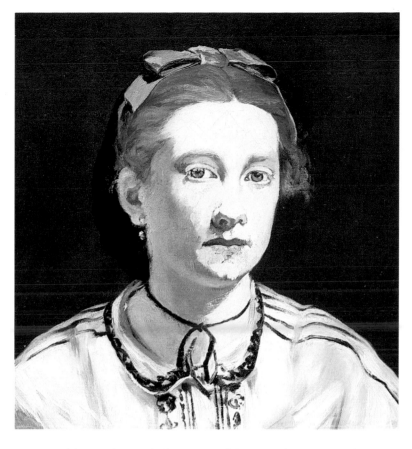

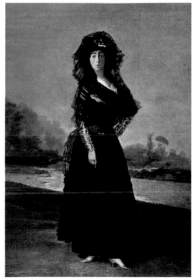

Francisco de Goya: *The Duchess of Alba*, 1797
Oil on canvas, 210 x 149 cm
New York, The Hispanic Society of America

Romans of the Decadence and *The Baptism of the Imperial Prince*. His subjects were banal, and he painted on a dark ground obtained by mixing bitumen and cobalt. To this method the young Manet was perfectly averse; he built his paintings from bold touches of pure colour, and it was he who, ten years before Monet, invented the "pure colour" rule that underpinned Impressionism. Manet emancipated himself from Couture's teaching by copying the masters that he admired and applying his "pure colour" technique to these reproductions. Museums were the school in which he discovered his talent. In the Louvre, he copied the Tintoretto *Self-Portrait*. Cézanne spoke of this copy, comparing Tintoretto to Shakespeare or Beethoven as "a moral and intellectual landmark", whose "works will surely never be surpassed", but which set the artist on a "tireless quest for means of interpretation".

Manet travelled the length and breadth of Europe in search of masterpieces. In 1856, he was overwhelmed by the works of Velázquez in Vienna. It was to be a decisive influence; the superlative portraits sent by Philip IV to the Vienna court were a revelation to Manet. The astounding economy of means that allowed Velázquez to obtain great intensity from very few tones was a lesson that Manet took to heart: the greatest colourists, he realised, were sparing in their use of colour. Antonin Proust remembers Manet looking up while copying the Louvre's *Little Cavaliers* (then attributed to Velázquez) and exclaiming: "Ah, it's so clear and precise! Puts you right off all those stews and gravies!"

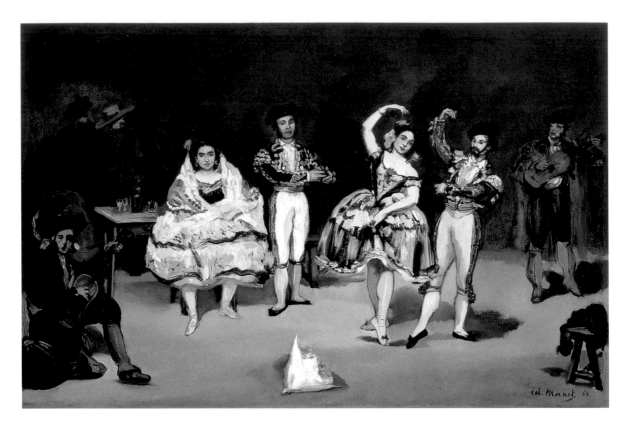

The Little Cavaliers, after a picture then
attributed to Velázquez, 1861–1862
Oil on canvas, 47 x 78 cm
Private collection

AT THE TOP:
Spanish Ballet, 1862
Oil on canvas, 60.9 x 90.5 cm
Washington (DC), The Phillips Collection

Manet's *espagnolisme* reached fever pitch in the 1860s; any subject was good so long as it was Spanish. Rejected by the Salon, and laid out in a shed, Manet's output of the decade astonished Courbet: "So many Spaniards!" he exclaimed. When a Spanish ballet troupe came to Paris, Manet was quick to paint *Lola de Valence* (p. 14), posing her in the same position as Goya's *Duchess of Alba* (p. 15). Her magnificent costume, glittering with a thousand spangles, made an ideal subject for him. He loved to make his splashes of colour chime one against another, and sought to restore black as a colour in its own right. Niggardly with his praise, Baudelaire nonetheless celebrated his friend's first masterpiece in a notoriously erotic quatrain, which contributed no little to Manet's sulphurous reputation: "My friends, among so many beauties,/Desire, I conceive, may hesitate;/But in Lola de Valence see scintillate/Surprise! A charming jewel of black and pink." Manet was less confident when it came to painting the troupe as a whole. The vacillating forms of *Spanish Ballet* (p. 16) straggle across the canvas, some raising their arms in a bashful adumbration of dance. Composition drove Manet to distraction. Only when the structures of an earlier master underpinned his work was he successful: Goya's *Maja vestida* in *Young Woman Reclining in Spanish Costume* (p. 13), Rembrandt's *Bathsheba* and Boucher's *Diana at Her Bath* (both p. 11) in *Surprised Nymph* (p. 10), or Watteau and the Le Nain brothers in *Old Musician* (p. 17).

Two people had played a decisive role in the development of Manet's Spanish period, which reached its culmination around 1862. First and foremost was a professional model, Victorine Meurent, who entered Manet's life and work simultaneously, successively becoming *Mlle Victorine in the Costume of an*

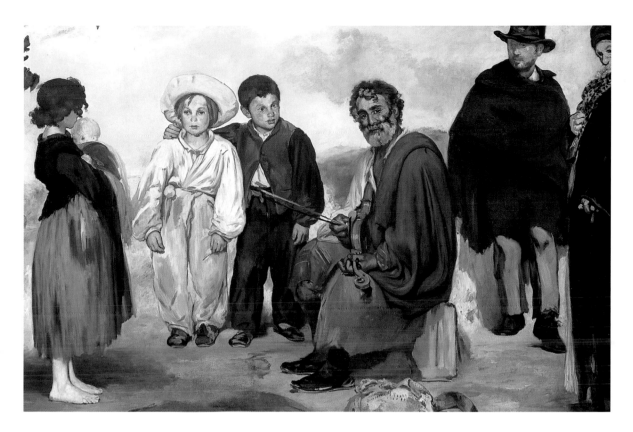

Espada (p. 6), and the nudes of *Déjeuner sur l'herbe* (pp. 2 and 24/25) and *Olympia* (pp. 20–23). She later posed for the heroine of *Railway* (pp. 58/59) before falling into oblivion. This "strawberry blonde with milky skin" (as Blanche describes her) was perfectly suited to modelling the unconventional feminine protagonists for whom Manet liked to set the scene almost like a film-director. For Manet, the attraction of *Gypsy with a Cigarette* (p. 8, 1862) was not just the costume and pose, but a natural bravado, also found in his *Espada* (p. 6). *Gypsy* was a thoroughly modern subject: a liberated woman unafraid of taboos, colourful and spontaneous. Sixteen years later he painted *The Plum* (p. 74), which similarly depicts an unconventional young woman, this time on the background of a fashionable café.

The other person was, of course, Manet's friend Baudelaire. In "Le Boulevard", Baudelaire emphasised the connection between this Spanish vein and "modern reality". Castigating the "the absurdities for which French painting is notorious [...] niminy-piminy painting, pretty things, inane things, convoluted intricacy and the pretentiousness of the student daub", he cited against them this scion of "the genius of Spain". Manet's *Spanish Singer* (p. 11) had, he said, already caused a "sensation", and "In the next Salon, we shall see several paintings of his imbued with the strongest Spanish savour, persuading us that the genius of Spain has taken refuge in France".

The Old Musician, 1862
Oil on canvas, 186 x 247 cm
Washington (DC), National Gallery of Art,
Chester Dale Collection

PAGE 18/19:
Music in the Tuileries Gardens, 1862
Oil on canvas, 76 x 118 cm
London, The National Gallery

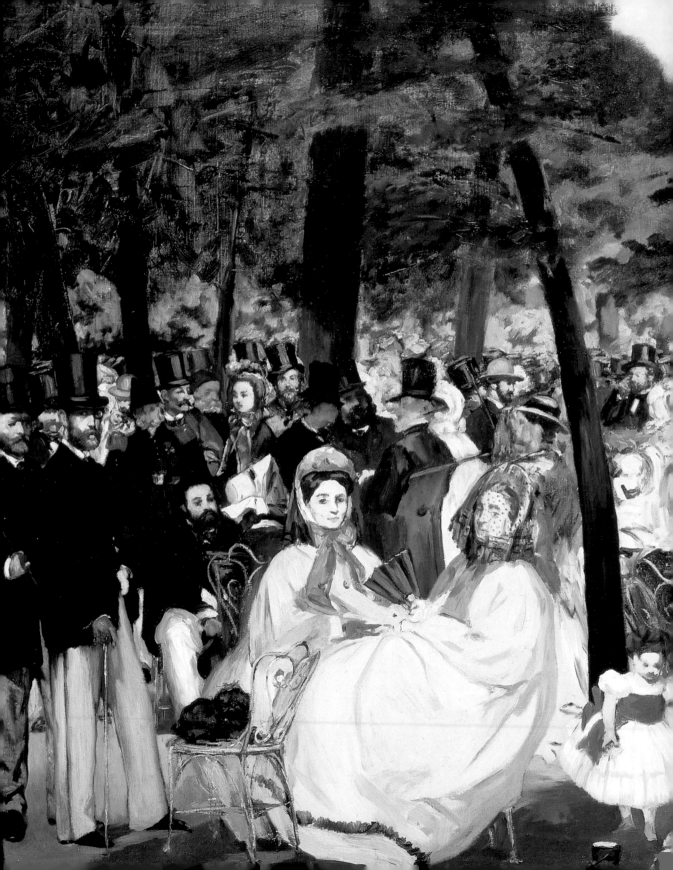

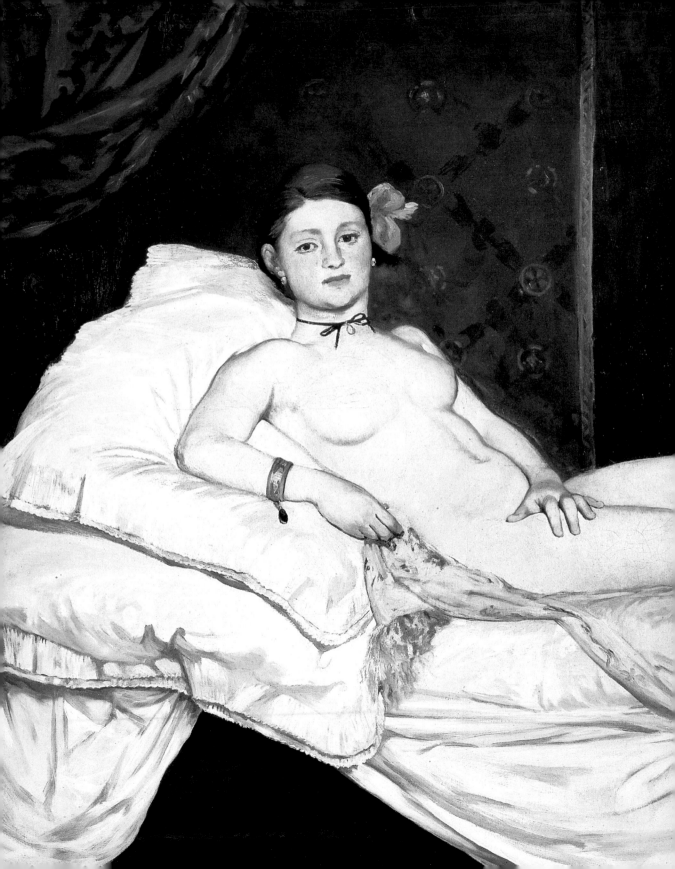

Modernity: Scandal and Triumph
1863–1868

Who else? Who but the well-bred, courteous Édouard Manet could have put before an astonished public that "female gorilla", that "gamy courtisan", *Olympia* (pp. 20–23)? Public and critics were, for once, unanimous. There could be no two ways about it: Manet had violated a taboo. He had painted neither a pneumatic goddess nor a startled nymph – the Salon's customary fare – but a common or garden whore receiving a punter. For the first time, here, on canvas, was a truly naked woman, in flesh and blood, as if she had just this minute stepped out of her clothes. And therein lay the scandal. The spectacle Manet revealed was one of vices it was proper to conceal. True, Plato had already argued in the *Symposium* that there were two sorts of Venus, the celestial and the vulgar. And Renoir soon afterwards entered another defence: "Let the nude woman arise from ocean or bed, call her Venus or Nini, nothing better has ever been invented". The simple fact is that *Olympia* was not a nude; she was naked. Painting had seen nothing of the kind since Rembrandt's *Bathsheba* (p. 11).

Manet protested his innocence, but there is no reason to credit him. Every great artist knows exactly what he or she is doing. Moreover, there was a hint of perversity to Manet's painting. The slender body of Victorine Meurent, his model and mistress, encouraged a misinterpretation; only nineteen years old at this point, her breasts fully developed but her hips those of an adolescent, she might have been a child sold into prostitution. Today, we should speak of paedophilia, and perhaps, indeed, of racism, in this association of young white mistress and black slave. On the latter point, we simply note that Manet's *Olympia* belongs in a long tradition of odalisques with slaves. The cat is black as ink, and much ink was expended on it. Françoise Cachin, Curator at the Musée d'Orsay, tells us: "Manet cannot have been unaware of the multifarious provocation constituted by that black cat. X-rays show that it was painted in as an afterthought, probably a short while before it was send to the 1865 Salon, and thus more than a year after the picture was finished. This in itself shows that Manet's attitude was ambiguous." Since composition was not his *forte*, Manet took it ready-made from the *Venus of Urbino* (p. 22), hoping, no doubt, to shield himself from the critical brickbats by invoking Titian's name. As if this were not enough, he replaced the innocuous lapdog sleeping at the feet of Titian's Venus with a black cat, its back arched and tail raised. The black cat is often thought of as Satan's minion, and French *chatte* and English *pussy* designate precisely what *Olympia*'s left-hand so emphatically refuses to the spectator's eye. Zola alleged artistic reasons; determined to protect his friend from public sarcasm, he assumed an innocent air, and claimed that this Beelzebub, this notorious pussy-cat, had come into

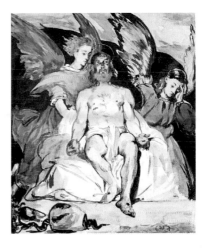

Dead Christ with Angels, c. 1865–1867
Graphite, watercolour, gouache, pen and
Indian ink, 32.4 x 27 cm
Paris, Musée du Louvre, Cabinet des Dessins

PAGE 20:
Olympia (detail of page 22), 1863
Oil on canvas, 130.5 x 190 cm
Paris, Musée d'Orsay

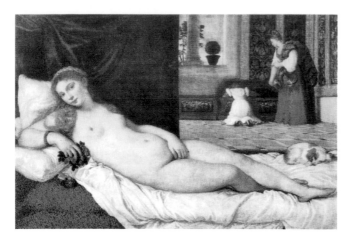

MANET.
La Naissance du petit ébéniste.
M. Manet a pris la chose trop à la lettre :
Que c'était comme un bouquet de fleurs !
Les lettres de faire-part sont au nom de la mère Michel
et de son chat.

MANETTE, ou LA FEMME DE L'ÉBÉNISTE, par MANET.
Que c'est comme un bouquet de fleurs.
(Air connu.)

Ce tableau de M. Manet est le bouquet de l'Exposition. — M. Courbet est distancé de toute la longueur
du célèbre chat noir. — Le moment choisi par le grand coloriste est celui où cette dame va prendre un bain
qui nous semble impérieusement réclamé.

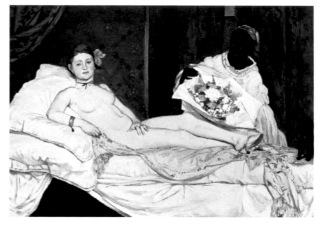

AT THE TOP, LEFT:
Titian: *The Venus of Urbino*, c. 1538
Oil on canvas, 118 x 167 cm
Florence, Galleria degli Uffizi

AT THE TOP, RIGHT:
Cham: *The Birth of the Little Cabinet Maker*,
caricature in "Le Charivari", 1865

LEFT:
Bertall: *Manette* ou *The Cabinet Maker's Wife*,
caricature in "L'Illustration", 1865

RIGHT AND DETAIL PAGE 23:
Olympia, 1863
Oil on canvas, 130.5 x 190 cm
Paris, Musée d'Orsay

being simply because Manet needed a dash of black at that point; another swathe of black had, he said, been necessary where the black servant stood. His words are less relevant than Baudelaire's, whose spirit haunts the entire work: "I should like to have lived with a young giantess/Like a voluptuous cat at the feet of a queen". Seeing the bracelet on Victorine's wrist, should we not hear: "My dear one was naked, and, knowing my heart/Wore nothing about her but sonorous jewels'? Manet was determined to be modern, but the modernity remained Romantic and Baudelairian. The scandal was not to his taste, but was he really surprised by it?

Manet owed the "acceptance" of his *Olympia* to Napoleon III. The Emperor was more open than is generally thought, and, indignant at the excessive severity of the Salon jury, had ordered that all the rejected submissions should feature in a separate section. Two wardens were immediately required to protect the painting from the canes of irate visitors. "Only the precautions taken by the administration prevented the painting being punctured and torn", Antonin Proust confirmed. Champfleury rejoiced in the scandal: "Like a man falling into snow, Manet has made his mark in public opinion." Degas, caustic as ever, observed: "Now you're as famous as Garibaldi". But Manet, for all his new-found notoriety, had not been awarded a Salon medal. He was the idol of the Impressionists, certainly, but that was no consolation. Medals rained down on the well-trained

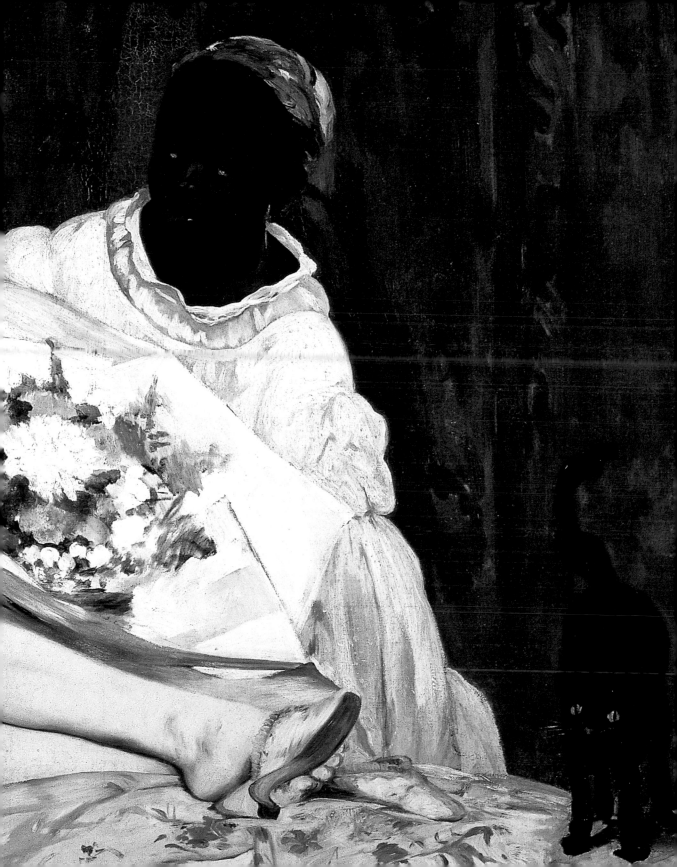

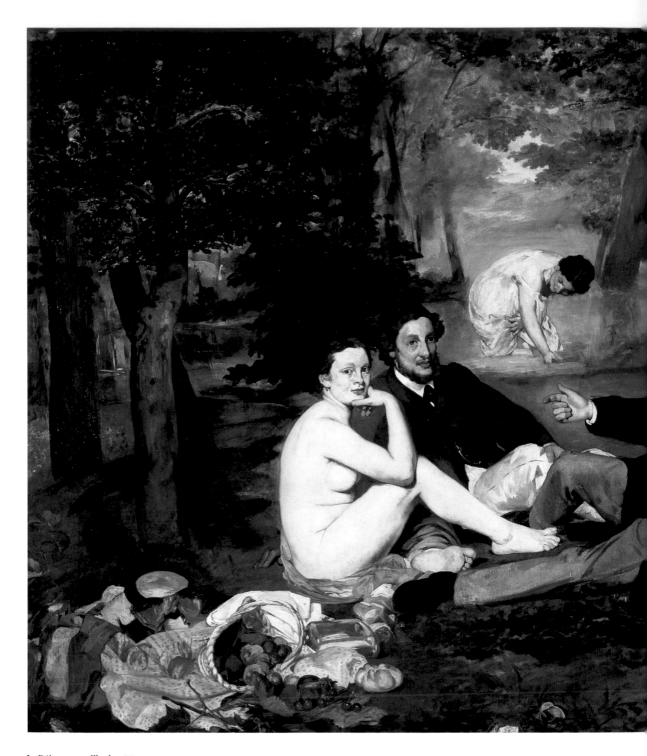

Le Déjeuner sur l'herbe, 1863
Oil on canvas, 208 x 264 cm
Paris, Musée d'Orsay

Marcantonio Raimondi: engraving after
The Judgment of Paris by Raphael (detail), c. 1525
Paris, Bibliothèque Nationale, Cabinet des Estampes

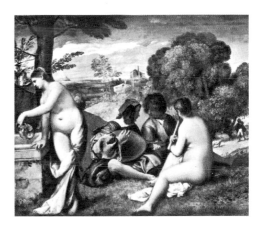

Titian (then attributed to Giorgione):
Concert champêtre (detail), c. 1510–1511
Oil on canvas, 110 x 138 cm
Paris, Musée du Louvre

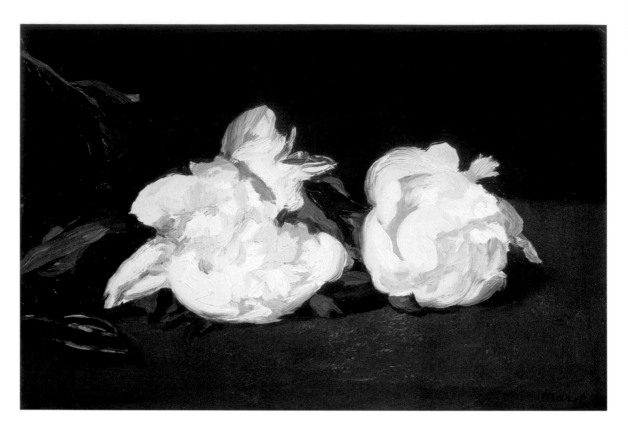

painters who knew just how far draperies could be parted, just how much flesh a River Nymph or Vestal could display. Artists such as Gérôme or Bouguereau exposed enough of their Christian martyrs to excite the appetite of lions and Salon spectators alike. Delirious nudity might, as "Bacchant" or "Truth", make a superlative show of breast and haunch, and not a word of complaint would ensue. No one was taken in by this. But the conventions had to be observed. A song-writer of the time wrote: "Since I've been going to the studio/I've shown it to Monsieur Bouguereau/Monsieur Bonnat's done it in oil/Monsieur Gervex in pastels and chalk/I'm the object of great artists' toil/I'm really an excellent nude, in sum,/And by evening I feel the lack/If by day no one's seen my … er … back".

But to show one of society's outcasts – a *demi-mondaine* – in her own home, wearing only the costume of her trade, apparently awaiting her next client, was an outrage. *Olympia* lay stretched out in readiness for the next episode in the transaction. The bouquet announced the punter, who might perfectly well be visiting the Salon on the arm of his wife. Jules Clarétie waxed indignant in the pages of *L'Artiste*: "What is this sallow-bellied odalisque, this ignoble model, picked up I know not where to represent Olympia? What Olympia? A courtesan, no doubt. Monsieur Manet will not be accused of idealising gambolling virgins, he who thus transforms them into sullied virgins." And yet, for Manet, the Salon remained "the true battlefield, there one must try one's strength … my prices are not high, but dealers and art-lovers shun me. It is particularly depressing to see how little interest is elicited by works of art without a steady list-price." Then, as now, the price-label defined the painting's worth. But things change, and prices with them. Manet was vindicated. When Claude Monet began fund-raising to

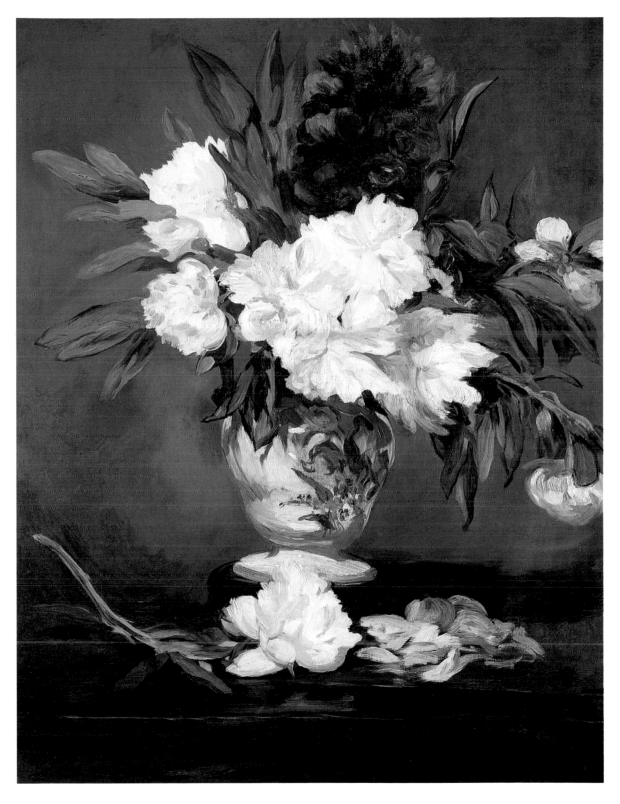

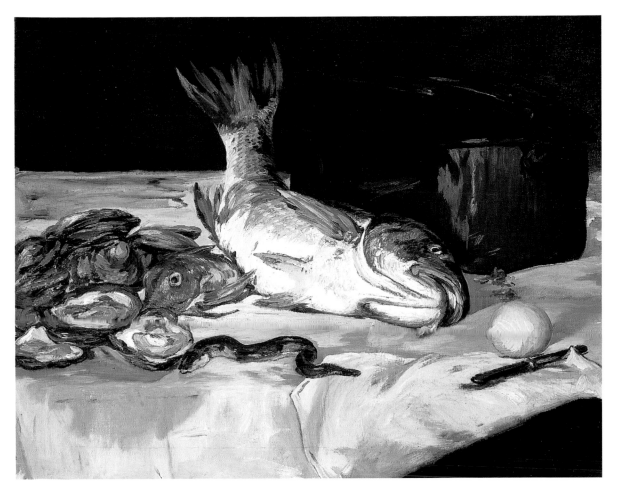

AT THE TOP AND DETAIL PAGE 28:
Still-life with Fish, 1864
Oil on canvas, 73.4 x 92.1 cm
Chicago (IL), The Art Institute of Chicago,
Mr. and Mrs. Lewis Larned Coburn Memorial
Collection

present *Olympia* to the French State in 1890, he was, he felt, merely giving the painting its due. And in 1932, Léon Daudet wrote: "Barracked and spurned, the *Olympia* was described as unspeakable filth, an offence against decency and obscene beyond words. It has now calmly taken its place among the most beautiful pictures in the world, alongside Goya's *Desnuda*."

Horrified by the effect of his painting, Manet appealed to Baudelaire, who was then in Brussels: "I wish you were here with me, my dear Baudelaire; I'm bombarded with insults. […] I should have liked your verdict on my pictures". Baudelaire was an old hand at scandal; *Les Fleurs du Mal* had been fined for offense to public morals in 1857. Trying to restore Manet's courage, he preferred severity to compassion: "So I must again tell you about yourself. I must again convince you of your own worth. What you ask is really too foolish. They make fun of you; you are irritated by the jokes; they are incapable of doing you justice, etc, etc. Do you think you are the first man ever to experience such things? Is your genius greater than that of Chateaubriand, or Wagner? And were they not mocked? They survived. And lest I inspire excessive pride in you, let me say that these men are, each in his own way, exemplary figures in a very distinguished field. You, by contrast, are merely the finest painter in the decrepitude of your art. I hope you will not resent this frank appreciation. You know I am your loyal

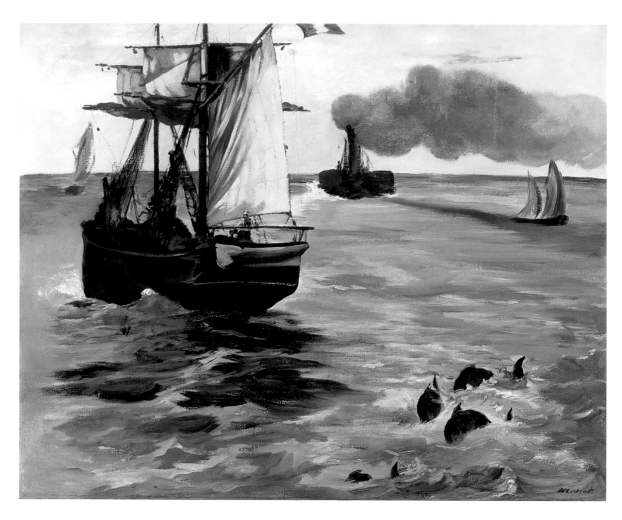

friend." Was the lash of Baudelaire's tongue beneficial? Was Manet reassured to be merely the "finest painter in the decrepitude" of painting? Or was Baudelaire simply describing the fate that he thought must overtake modern painting?

Olympia, painted in 1863 and exhibited two years later, symbolises Manet's modernity. *Le Déjeuner sur l'herbe* (pp. 2 and 24/25), painted in the same year as *Olympia*, foreshadows Impressionism. Manet's first title had been *Le Bain [The Dip]*, as if he were asserting his pioneering status in the outdoor painting adopted by the Impressionists as their creed. Manet, finding the creation of balanced structures problematic as ever, borrowed his composition from Raphael and Titian (p. 25). This time he knew a scandal would result. "Apparently I should paint a nude," he said at Argenteuil. "Fine! I shall make them a nude in a transparent atmosphere, with people like the ones we see down there. They'll slaughter me. Well, they can say what they like!" All the same, when he sent the *Déjeuner* to the Salon, he still entertained hopes of a medal. He was, as he expected, slaughtered. It was intolerable to present such a scene without the slightest veil of mythology: one woman naked alongside two fully-dressed art students, while another woman cooled off in the water after who knew what exertion. In *Le Figaro*, Charles Monselet wrote a conclusive verdict, whose tenor has been

Marine View (Seascape with Porpoises), 1864
Oil on canvas, 81 x 100 cm
Philadelphia (PA), Philadelphia Museum of Art, Bequest of Anne Thomson in memory of her father, Frank Thomson, and her mother, Mary Elizabeth Clarke Thomson

PAGE 31:
The Battle of the "Kearsarge" and the "Alabama", 1864
Oil on canvas, 134 x 127 cm
Philadelphia (PA), The John G. Johnson Collection, Philadelphia Museum of Art

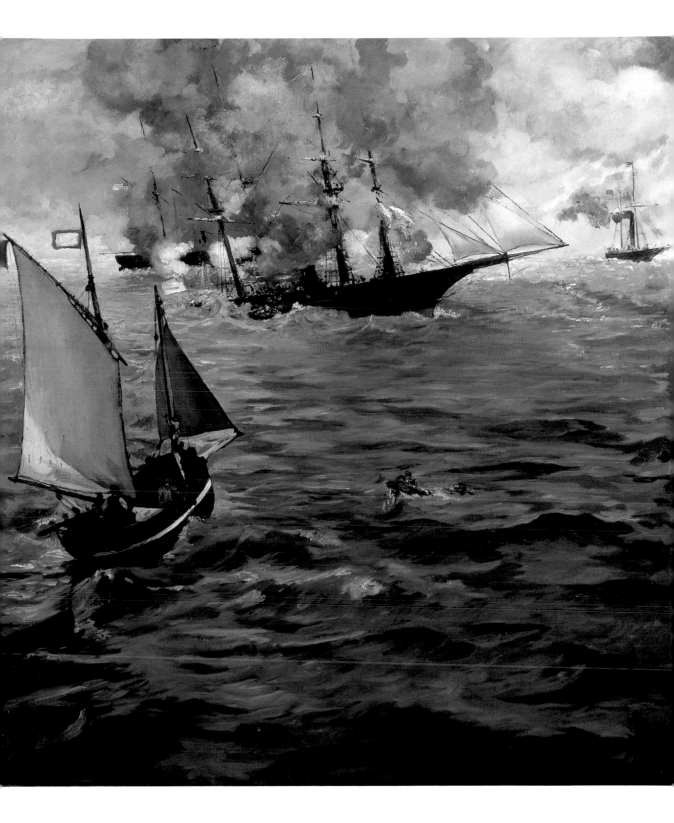

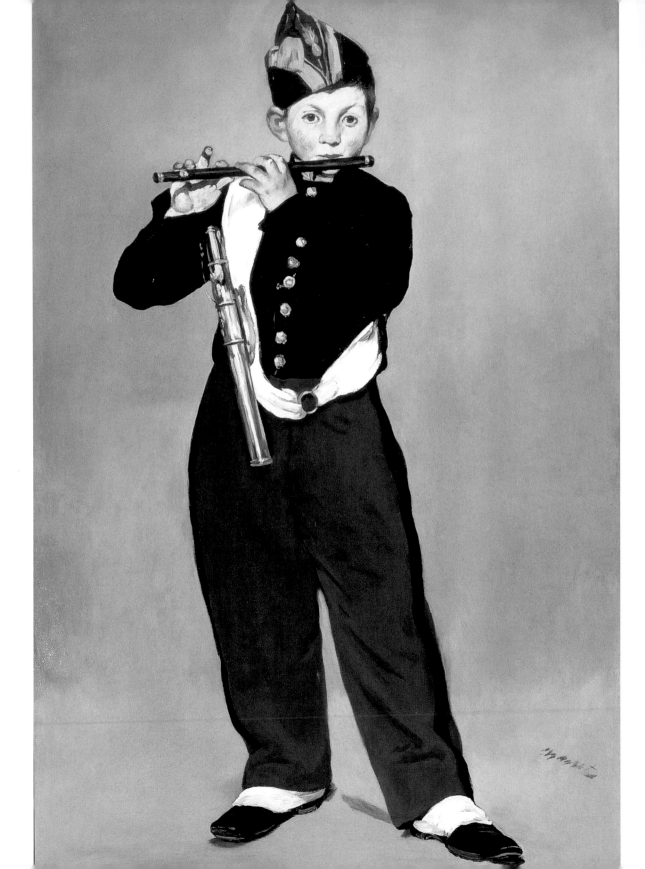

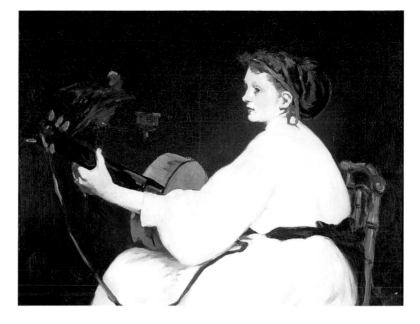

Bouffon (French tarot card), 19th century
Paris, Bibliothèque Nationale,
Cabinet des Estampes
Manet's use of layered areas of flat colour
prompted Courbet to remark that a painting
wasn't a playing card. Manet's rejoinder: 'Yes,
yes, we all know Courbet's ideal is a billiard
ball!'

transformed into praise by the passing years: "Monsieur Manet is a pupil of Goya and Baudelaire. He has already earned the revulsion of the bourgeoisie."

Zola, having taken pains to see in the black cat and black servant-woman of *Olympia* no more than well-judged applications of colour, maintained his wilful blindness on behalf of *Le Déjeuner*. "Great God! How indecent can one be: a woman without a stitch of clothing between two fully-clothed men! […] The public thought the arrangement of the subject savoured of the artist's indecent and provocative intentions, when he merely attempted vivid contrasts and well-defined volumes … What we should see in this painting is not a *Déjeuner sur l'herbe*, but the landscape as a whole, its broad, substantial foreground and the lightness and delicacy of the background; the firm flesh moulded by great swathes of light […], a little corner of the countryside rendered so simply but so exactly". Zola's negative anticipates Magritte's "This is not a pipe". His description is excellent; it does full justice to Manet's new technique, which was also criticised as running counter to the standard studio prescriptions. It does less justice to Manet's blithely provocative character – the artist referred to the work in private as *la partie carrée*, usually translated "wife-swapping" – as if marriage were relevant here. Courbet's *Young Ladies on the Banks of the Seine* (1856), one of Manet's sources, had also been greeted with horror in its time. But even Courbet had never been so calmly revolutionary; the "dubious taste of his subject" had been virulently attacked, but Courbet's young ladies had at least restored their clothing after their friends" departure. Courbet had made it clear that his young ladies were not above temptation; they were not water nymphs but young working-girls, and had not spent the morning picking flowers. Courbet's "poems of carnality" publicly revealed one aspect of the hypocrisy indulged by the Empire that he so detested. But Manet had gone one step further by transforming Courbet's innuendo into a "realistic" scene. This was more provocative still. Manet's women were not nude, they were undressed. They were already what was later termed "living art". Their clothes lay piled up in the foreground, in a superlative still-life. It was as if a photographer had surprised them *in flagrante*,

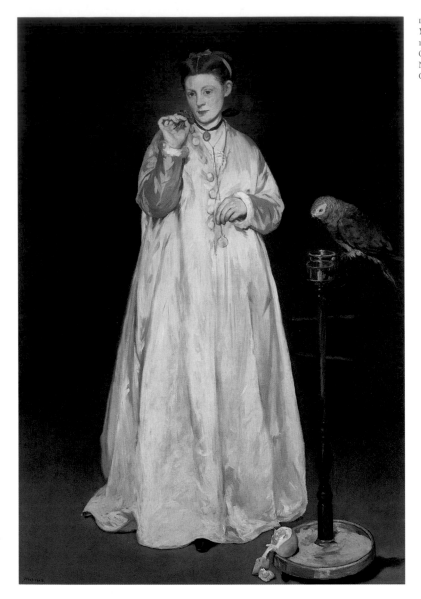

LEFT AND DETAIL PAGE 35:
Young Lady in 1866 (Woman with a Parrot),
1866
Oil on canvas, 185.1 x 128.6 cm
New York, The Metropolitan Museum of Art,
Gift of Erwin Davis

and Manet had sought to blackmail the bourgeoisie as a whole with the resulting document. The critics of the time were perfectly aware of this, as their first salvoes show: "Manet will show himself talented the day he learns draughtsmanship and perspective, and tasteful when he ceases to choose his subjects for their scandal-worthiness. [...] We cannot deem it perfectly chaste to seat a young woman in woodland, surrounded by students in beret and paletot, and clothe her in nothing but dappled light. This is a secondary question, and it is the intention rather than the composition it inspired that I regret. [...] Monsieur Manet wishes to attain fame by astonishing the bourgeoisie [...] His taste is corrupted by love of the bizarre". Is there any difference between this and the campaigns waged today by certain "right-thinking" minorities in their effort to impose their sexual taboos on an indifferent majority?

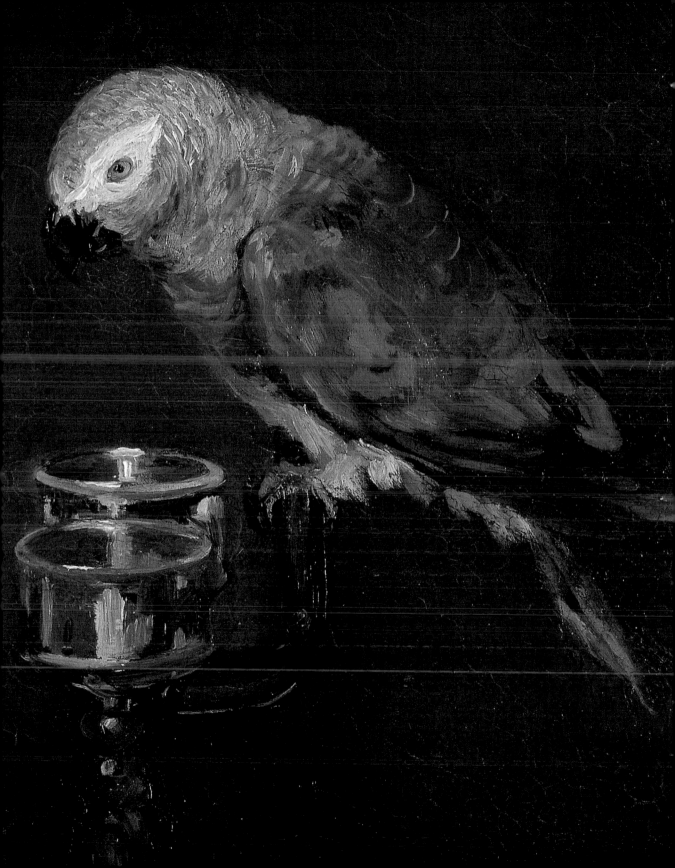

The World Fair of 1867, 1867
Oil on canvas, 107 x 97 cm
Oslo, Nasjonalgalleriet

The successive scandals conferred on Manet a reputation for provocation that rather overshadowed his art. When he exhibited a *Jesus Mocked by the Soldiers* (from a series that includes *The Dead Christ with Angels*, p. 21) alongside *Olympia*, the public identified with Christ and saw itself "mocked" by the artist. This was not art but war. Yet Manet's double submission merely imitated a gesture falsely attributed to Titian by Charles Blanc, who had the story from Aretino. Titian, they claimed, had presented the Emperor Charles V with a *Christ Mocked* and a *Venus*, thus simultaneously flattering his piety and his sensuality.

The technical daring and thematic insolence of the *Déjeuner* have become one of the clichés of art history. Yet the work is by no means perfect, and Cézanne, comparing it with Titians's *Concert champêtre* in the Louvre, regretted the fact. "You see, Manet should have added to the *Déjeuner sur l'herbe* I don't know quite what, a sense of that nobility, the unknown something that here places all the senses in paradise". Hofmann sees the work as "dialectically, a painting of unreconciled contrasts, which sets off the natural feminine world against the artificial and civilised world of men". For Farwell, the image is the realisation of a masculine fantasy, a pastoral paradise reclaimed in contemporary terms; he sees it as the first in a line continued through Matisse's *Joy of Life* (1905/06) to Picasso's *Demoiselles d'Avignon* (1907). Picasso certainly appreciated the work, painting a whole series of variants on it.

Cézanne focused on the bouquet in *Olympia* and the still-life in the foreground of the *Déjeuner*; these were, he felt, great painting, and displayed Manet's painting skills at their purest. For the critics, it was a further outrage that Manet accorded equal weight to objects and figures. One of them wrote, with unusual perspicacity: "His current vice is a sort of pantheism, which sometimes accords greater importance to a bouquet than to the physiognomy of a woman, for example in his famous picture of the *Black Cat*". Zola had carefully censored aspects of Manet's student-humour in his "black cat" and *partie carrée*, but he was quite right when he described the painter's uncomplicated procedure: "A paint-

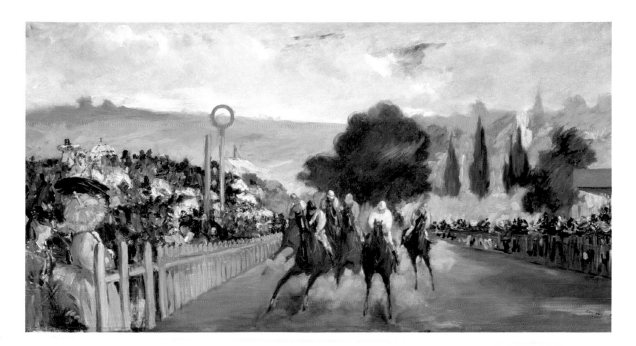

The Races at Longchamp, 1867 (?)
Oil on canvas, 43.9 x 84.5 cm
Chicago (IL), The Art Institute of Chicago,
Mr. and Mrs. Potter Collection

ing for you is simply a pretext for analysis. You needed a naked woman, and you chose Olympia, the first one to come along; you needed bright, luminous areas, so you put in a bouquet; you needed black passages, and you put a negress and a cat in one corner. What does it mean? You scarcely know, and neither do I. What I do know is that you have contrived to make an admirable painter's work, the work of a great painter, […] to energetically convey in a specific language the truth of light and shade, the realities of the objects and creatures." This is irresistibly reminiscent of a remark that Picasso made to Hélène Parmelin: "You know, it's like stall-keepers in a market. You want two breasts? Fine! Here they are. […] What's required is that Monsieur should have to hand everything he needs. Then he can use his eyes to put them where they should go". This was why, in *Les Demoiselles d'Avignon*, he had painted a "profile nose in frontal face, I had to put it sideways, to designate it, to name it "Nose!".

"Even those most overtly hostile to the talent of Édouard Manet", Zola observed in 1867, "concede that he paints inanimate objects well". And even the extremely hostile Albert Wolff recognised the importance of still-lifes in Manet's work. In the Wildenstein *catalogue raisonné,* they account for a fifth of his *œuvre,* quite apart from the many pictures within pictures, such as the dress and basket in the foreground of the *Déjeuner,* the bouquet in *Olympia,* or the perch and lemon in *Woman with Parrot* (pp. 34–35). All of Manet's most important works contain a magisterial still-life, from the desk and passe-partout mounting in the *Portrait of Émile Zola* (p. 48), the arms and carefully laid table of *Luncheon in the Studio* (p. 50) to the mugs in *The Waitress* (p. 78) or the oranges in *A Bar at the Folies-Bergères* (pp. 88/89). On his return from Spain in 1865 Manet wrote to Baudelaire "I arrived back from Madrid only yesterday. At last, dear friend, I know Velázquez, and I can tell you that he is the greatest painter who ever lived". And of course Velázquez was the painter who raised the art of the *bodegón* to the highest level. The word originally meant a modest tavern serving food and drink, and in Castilian had become a synonym for "still-life" or "genre scene". Well be-

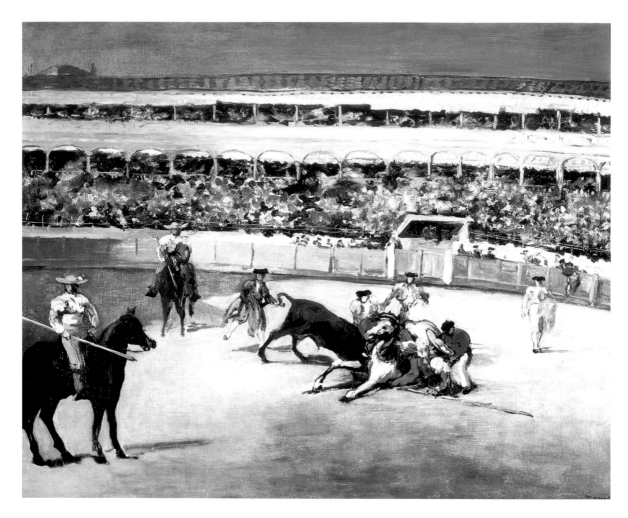

Bullfight, 1865–1866
Oil on canvas, 90 x 110 cm
Paris, Musée d'Orsay

fore Manet, Velázquez had lavished interest on objects and persons alike, expanding the limits of the still-life without descending into *trompe-l'œil*. In Velázquez, quality of painting transcended choice of subject, and this was meat and drink to Manet. Thus in Velázquez" *Christ with Mary and Martha* (1618), the protagonists appear in the depths of the painting, while the foreground is given over to servant-women preparing a meal of fish and eggs. One of his most famous paintings is entitled *Old Woman Frying Eggs* (1618). When taxed with his failure to attack loftier or more delicate subjects in which he might rival Raphael, he replied that he "preferred being the best at coarse subjects to being the second-best at delicate ones". This apparently humble ambition perfectly suited Manet, and it has been seen as the most obvious sign of the revolution he accomplished: the advent of a form of painting exclusively occupied with itself and freed of the tyranny of the subject. Thus Henri Loyrette, Director of the Musée d'Orsay, in his preface to the catalogue of the exhibition *Manet – Les Natures Mortes* (2001): "Like Cézanne, and like Monet, whom he influenced, Manet found in the flexibility and convenience of still-life a laboratory of colouristic experiment […] immediately implementing his discoveries in other compositions. By refusing any hierarchy within the picture and giving no less importance

PAGE 39:
A Matador (Matador Saluting), 1866–1867
Oil on canvas, 171.1 x 113 cm
New York, The Metropolitan Museum of Art,
H. O. Havemeyer Collection, Bequest of
Mrs. H. O. Havemeyer

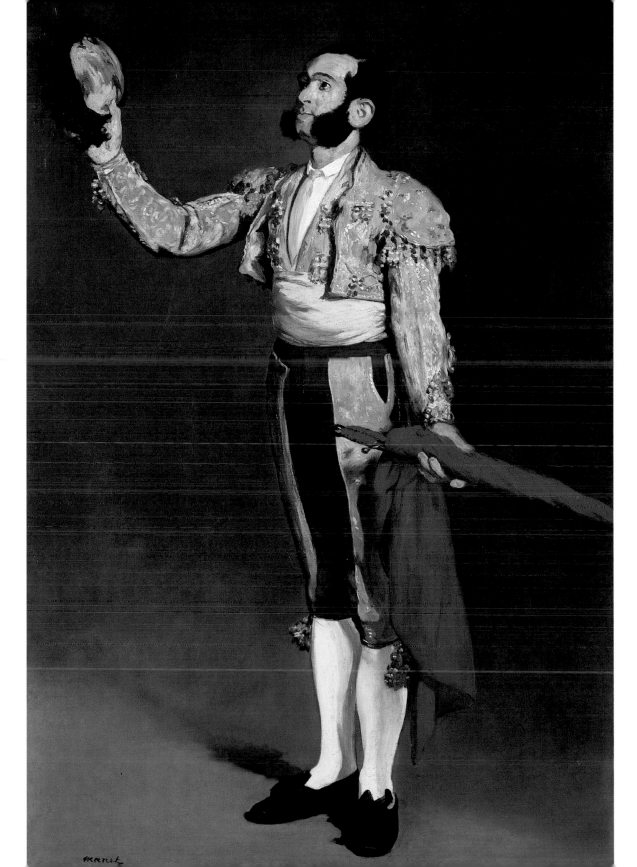

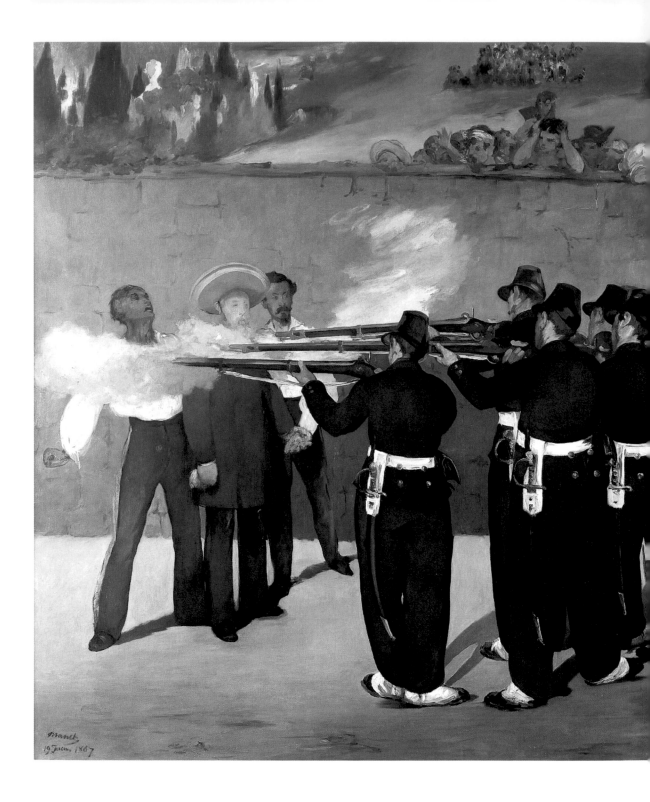

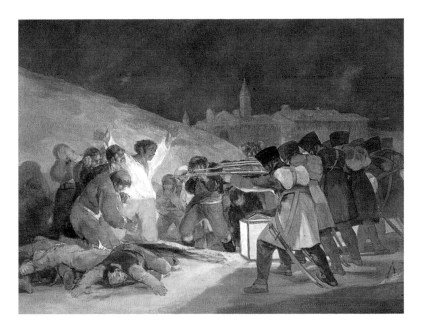

Francisco de Goya: *The Third of May*, 1815
Oil on canvas, 266 x 345 cm
Madrid, Musée du Prado

LEFT:
The Execution of the Emperor Maximilian, 1867
Oil on canvas, 252 x 305 cm
Mannheim, Städtische Kunsthalle

BELOW:
Photograph of the execution of Maximilian,
Emperor of Mexico

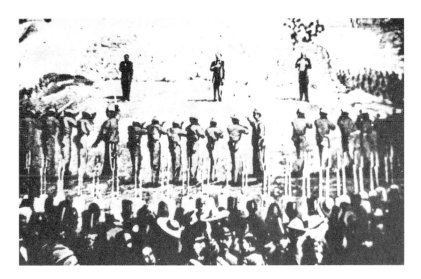

to the accessory than to the figure, Manet undoubtedly broke with academic rules, setting in train a revolution similar to that of his contemporary Flaubert". Is this equivalent to what Georges Bataille called "the destruction of the subject": the reduction of the figure to just one more motif on a par with a chair, a bouquet or any other object of contemporary experience? Bataille is perhaps answered by a remark attributed to Manet: "A painter can say anything he likes with fruit or flowers or even clouds". Georges Maurer said of the *Bar at the Folies-Bergère* (pp. 88/89) that it was "as much a still-life with figures as a figure-painting with a still-life".

Hence, for certain critics, the temptation to see in Manet no more than the inventor of pure painting, "painting-painting". This would be no mean achievement, but remains too exclusive and simplistic an interpretation. As the poet André Frénaud observes, the *Vase of Peonies on a Pedestal* (p. 27) is both a Spanish *bodegón* and a Flemish *vanitas*. It is, he says, "a narrative of the death of a flower, or, to use a medical term of greater precision-cruelty, its decay curve. The process is read from right to left, finishing in the centre", and leads from bud through blossom to the fallen petals. This is a legitimate and exact metaphysical interpretation, though it should not occlude the fact that Manet liked peonies and grew them in his garden. *Still-Life with Fish* (pp. 28–29), a *bodegón*, echoes a Chardin still life, but juggles with the yellow of the lemon and the red of the fish. *The Fifer* (p. 32), inspired by a playing card (see p. 33) is a further homage to Velázquez, whom Manet deemed "the painter of painters" in a letter to Fantin-Latour written from Madrid; we have it on Manet's own authority that it was based on Velázquez's *Portrait of a Famous Actor from the Time of Philip IV*.

In the fertile years that followed his two bombshells, the *Déjeuner* and *Olympia*, Manet experimented very widely. Sometimes he focused on giving form to colour and movement in works like *The Races at Longchamp* (p. 37) or *Bullfight* (p. 38); at others he was inspired by contemporary events, such as *The Battle of the "Kearsarge" and the "Alabama"* (p. 31) off Cherbourg. This episode of the American War of Independence made a considerable impression on public opinion. The work testified to Manet's "modernity", but was also an attempt to renew the theme of naval combat traditional in Dutch painting. It is, in fact, a battle between colour and light, where the blacks and the few dots of red enhance the tumultuous green of the waves. Barbey d'Aurevilly, Normandy-born and himself a sea-lover, saw this clearly: "Today, with his seascape of the *Alabama*, he has finally spliced the knot with nature! [...] Like the Doge of Venice, he has thrown a ring into the sea, and, believe you me, it is a ring of pure gold!"

We have seen that Manet's "playing card" technique was borrowed from Velázquez. It consisted in effacing the line dividing the ground from the background, thus restoring the work to the purity of a painted plane, and attaining Manet's own ideal: a picture must be first and foremost a painting. It attained perfection in *The Fifer*, and Manet hastened to apply it to *The Execution of the Emperor Maximilian* (pp. 40/41). This too derived from current affairs, and was a work of considerable ambition. Alas, for obvious reasons Napoleon III forbade its exhibition. In it, Manet makes play with his sources, borrowing his composition this time from Goya's *Tres de Mayo* (p. 41), but adding the faces of the people peeping over the wall from Goya's *Quinta del sordo*. Manet's soldiers, however, show no desire to hit their target; they aim parallel to the picture plane, putting their victims at no risk at all. Manet liked this effect so much that he repeated it during the 1870 war in *The Barricade* (p. 43).

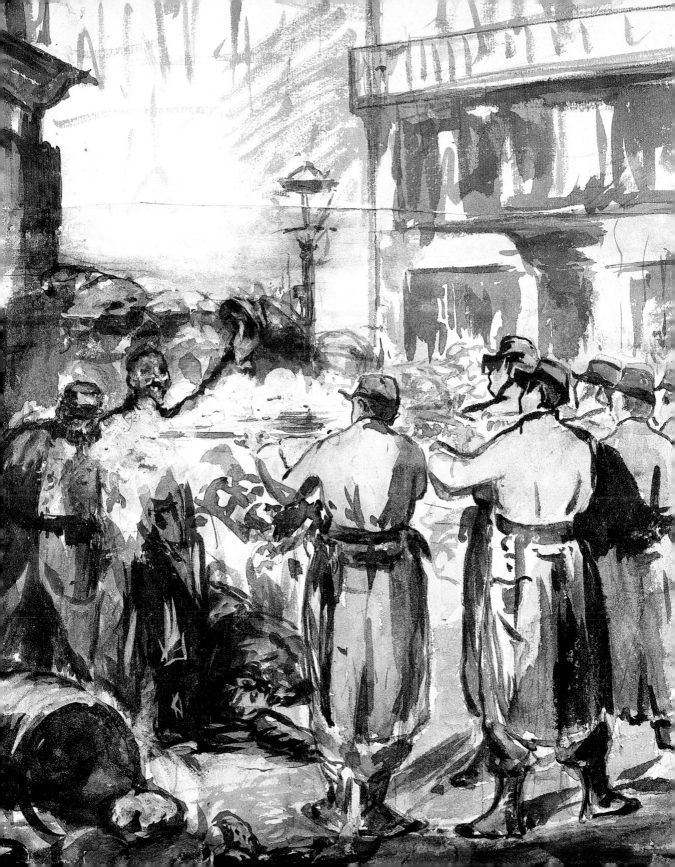

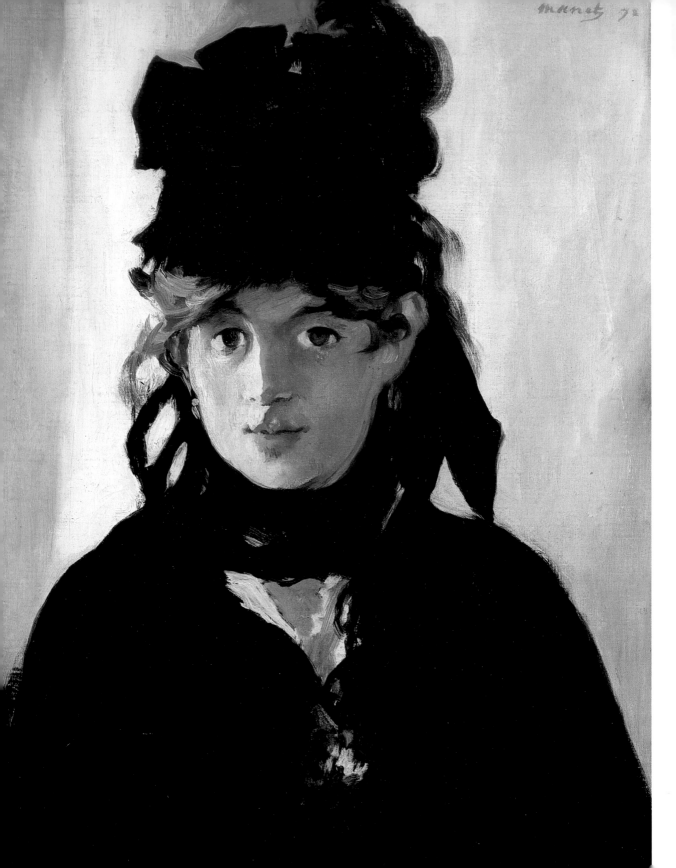

Godfather to
the "Manet Gang"
1868–1874

"Who is this Monet, who has apparently taken my name to exploit the stir I am making?" Thus Manet when, in spring 1865, Monet obtained an unexpected success with two seascapes at the Salon. The resemblance of their names ensured the proximity of their pictures, and Manet was much complimented – on paintings by Monet. He was not amused. André Gill made matters worse by captioning a caricature: "Monet or Manet? Monet. But it is to Manet that we owe this Monet. Bravo, Monet! Thank you, Manet!" At the Café Guerbois, the precursor soon learnt that Monet was neither forger nor usurper, but his devoted admirer. A analogous error occurred several years later, when Impressionism was at its height: Jules Clarétic, a less than percipient critic, described Manet's *Railway* (pp. 58/59) as "Impressionist" when it was exhibited at the 1874 Salon. One can imagine Manet's fury when discovering in *Le Bien Public* of 25 June 1874 that he was the "leader of the school of *taches* [spots, blots or stains]".

Encouraging a band of followers was the last thing on Manet's mind, especially a "school of the ignoble". But his opinion counted for little. The young painters soon to be termed "Impressionists" had all elected the holy prostitute *Olympia* as their sacrificial idol. Her triumph was complete. The scandal had not only made Manet's name, it established him as a rallying point for the new artists. At the Café Guerbois, near Montmartre, Manet became "the painter who held forth, as it were brush in hand – and was heard". The arrangement suited everyone. For journalists, his painting was a ready-made subject, while Manet was delighted to show himself serious, distinguished and classical in tendency, in contrast with his image as a coarse art-student avid for sensation. The young artists, meanwhile, badly needed a standard-bearer. There was no common program or doctrine. They had little in common but their ambition to render light as truthfully as possible through the use of pure colour without shadows, in the form of sensations recorded *in situ*. This each did as his temperament dictated. Manet was remote from them, and, though sympathetic, was unwilling to have his art confused with theirs. Their choice fell on him because, like them, he painted modern reality in bright colours, and was the embodiment of contempt for the Salon establishment that had closed its doors on them. Albert Wolff acknowledged Manet's role in *Le Figaro*; he had "pointed the way", and was to "modern art what the signpost is among the fields: he [had] directed the young artists of his time toward nature". Wolff later recorded Manet's amusement at this image: "One day, I analysed his place in modern art by saying that Manet was the signpost showing the young painters the road they should take. He was

Portrait of Eva Gonzalès, 1870
Oil on canvas, 191 x 133 cm
London, The National Gallery

PAGE 44:
Berthe Morisot with a Bunch of Violets, 1872
Oil on canvas, 55 x 38 cm
Paris, Musée d'Orsay

RIGHT AND DETAIL PAGE 47:
The Balcony, 1868–1869
Oil on canvas, 169 x 125 cm
Paris, Musée d'Orsay

highly amused by this summary of his position, and whenever I met him, he stood like a road-mender with his right arm extended to show me the way". Matisse's Fauvism and Picasso's Cubism contrived temporarily to maintain some unity of vision, but Impressionism was never a coherent movement. Artists as different in intention and character as Degas, Renoir, Van Gogh, Cézanne and Gauguin could not be shoehorned into a single category. Their most significant bond was the contempt in which they were held, the hostility of critics and authorities alike, and their commercial failure.

But at that level the bond was a strong one, involving much mutual assistance. Without Manet's aid, Monet and Renoir would have starved. Indeed, Manet, born to wealth, died a poor man, with no capital other than the works stored in his studio. Yet one fine day in 1872, he entered the Café Guerbois and threw out the question: "Tell me who it is that can't sell fifty thousand francs' worth of pictures a year?" "You can't!" came the chorused reply. They were wrong: Paul Durand-Ruel had just bought fifty-one thousand francs' worth of paintings from Manet. When the news reached the Paris art market, the conclusion was not that Manet's star was rising, but that Durand-Ruel had taken

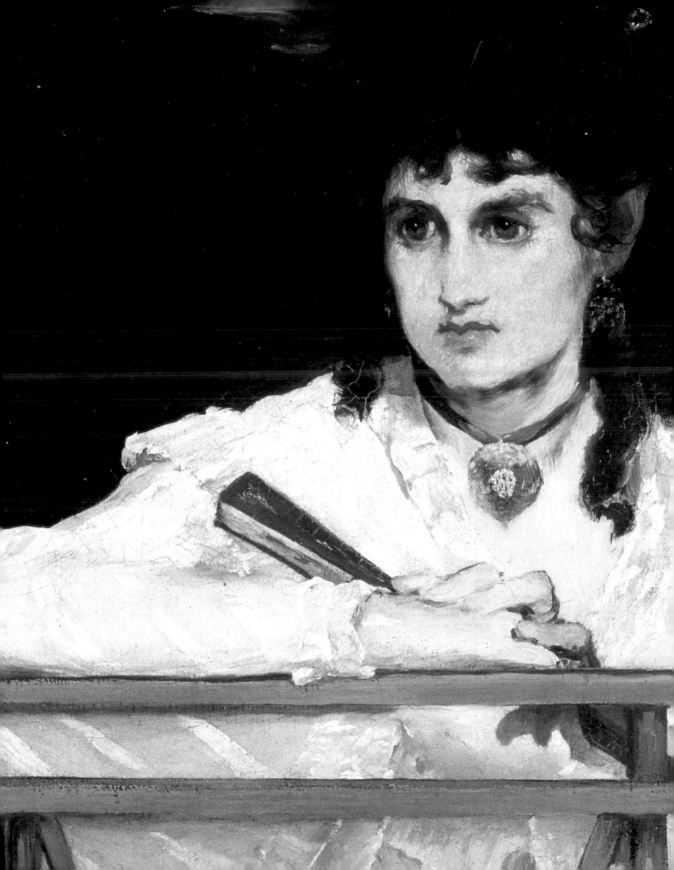

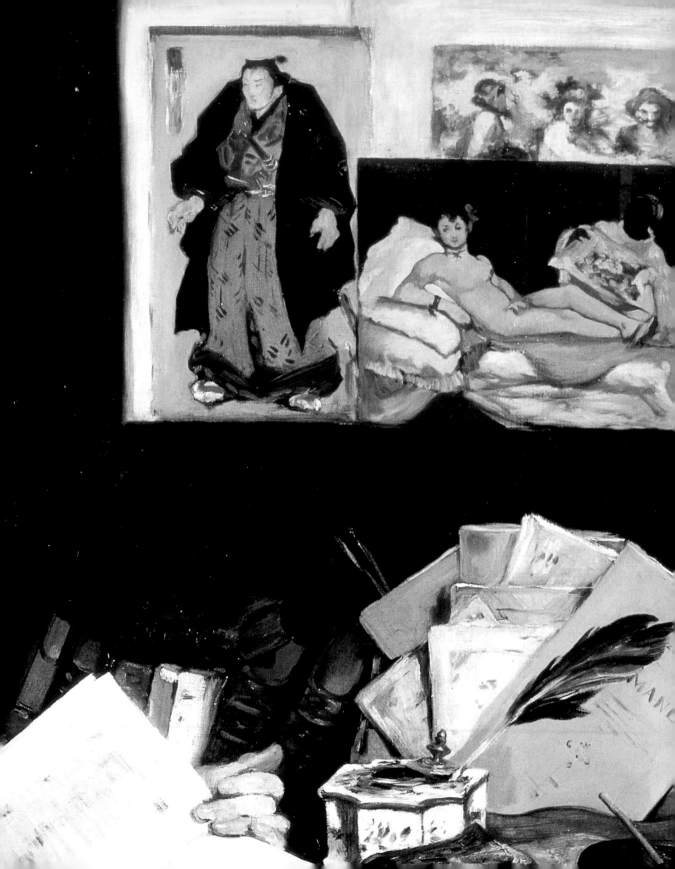

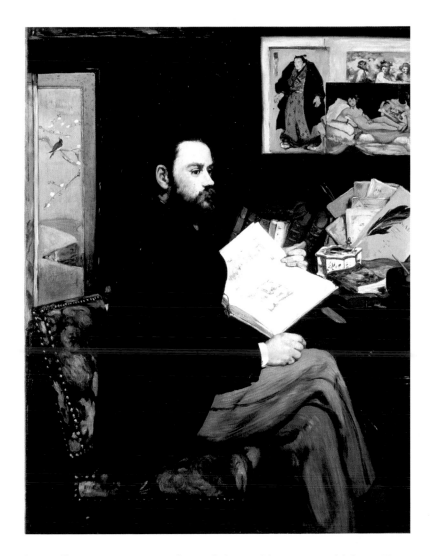

leave of his senses. Manet was, alas, rarely in a position to repeat this boast. He sold little, though he did obtain good prices. Asking 10,000 francs for *Olympia* frightened off one Italian admirer, but he sold *On the Beach* (p. 60) to Henri Rouart for 1,500 francs, *Lunch in the Studio* (p. 50) for 4,000 francs, *Lola de Valence* (p. 14) for 2,500 francs and *Le Bon Bock* (p. 55) for 6,000 francs.

Two people had featured strongly in the early part of Manet's life and art: Victorine Meurent and Charles Baudelaire. Baudelaire was now dead, and Victorine had moved on. But, just as Manet was becoming "godfather" to the "Manet gang", another woman and another writer emerged in their places. They were the painter Berthe Morisot and the author Émile Zola, another Café Guerbois regular. Zola constantly sang Manet's praise, throwing himself unreservedly into the battle against official art, and losing his place at *L'Événement* in consequence. "You know the effect of Monsieur Manet's pictures at the Salon," he wrote. "They blast holes in the walls. All around sprawl the sweetmeats of fashionable artistic confection: candy-sugar trees, pastry houses, gingerbread men and vanilla-cream women". During the 1866 Salon, he wrote: "Since no one else

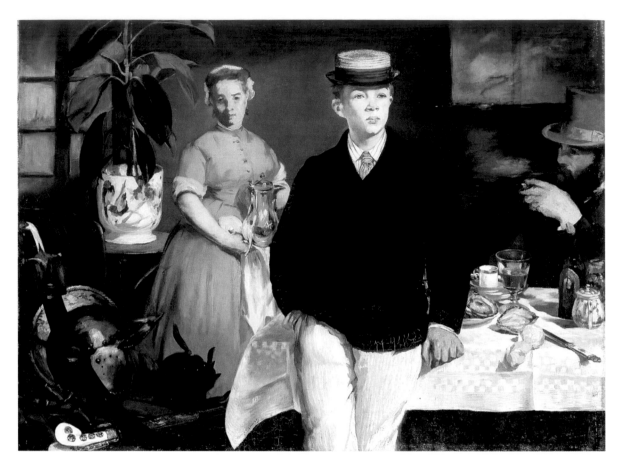

Lunch in the Studio, 1868
Oil on canvas, 118 x 153 cm
Munich, Bayerische Staatsgemäldesammlungen,
Neue Pinakothek

says it, I shall say it, at the top of my voice. I am so certain that Monsieur Manet will be one of the masters of tomorrow that, were I rich, I should consider it a bargain to buy up his entire works this very day." Zola, a childhood friend of Cézanne's though eight years his elder, received his just reward: he was portrayed by Manet in a painting that doubled as an aesthetic manifesto. The *Portrait of Émile Zola* (pp. 48–49) comprises two still-lifes. On the one hand, the wall decorations – a Japanese print, an engraving after Velázquez's *Drunkards*, and a reproduction of *Olympia* (who turns her head towards Zola as if in gratitude) – speak of Manet: "*Japonisme, hispanisme*, these are my sources. But my goal is modern painting." On the other, the masterly jumble of objects on the desk – porcelain inkpot, the sky-blue brochure that Zola had just written in Manet's defence – and the choice of one of Manet's favourite works of reference, Charles Blanc's *L'Histoire des peintres*, for Zola's reading-matter, constitute Manet's grateful homage to his devotee. Odilon Redon liked the work: "One looks at it despite oneself […] it bears the imprint of originality, it excites one's interest by its harmony, novelty and elegance of tone". But he went on to accuse it of "sacrificing the man and his thought to good craftsmanship, to the success of an accessory". It was, he concluded "more a still-life than the expression of a human character". But Manet had attempted to make his painting a manifesto of "pure painting", not a psychological portrait, and Redon's criticisms testify to Manet's success.

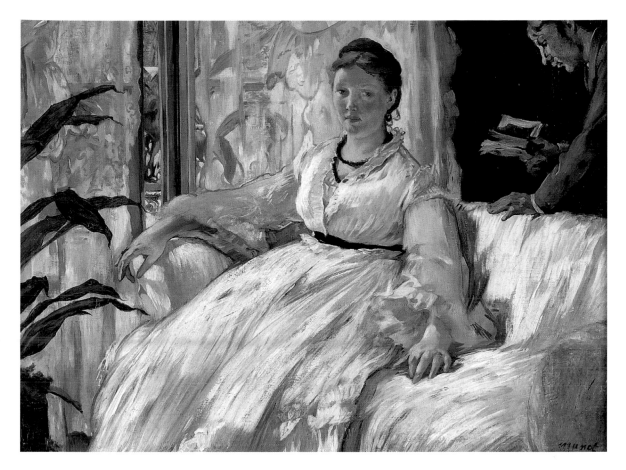

Reading, 1865–1873 (?)
Oil on canvas, 61 x 74 cm
Paris, Musée d'Orsay

Berthe Morisot, seated in the foreground of *The Balcony* (pp. 46–47), makes an impressive first appearance in Manet's *œuvre*. These are the large black eyes that made such an impression on Paul Valéry. Morisot wrote to her sister about the painting: "His paintings, as always, leave a savour of uncultivated or even unripe fruit. I really rather like them […] I've come out peculiar rather than ugly; it seems the words *femme fatale* have been going the rounds". Goya's *Tres de Mayo* had already been put to work in *The Execution of the Emperor Maximilian*; here Manet drew on Goya's *Majas on the Balcony*. His tendency to reduce the picture to a surface reaches a new extreme here; *The Balcony* has the hieratic frontality of Byzantine mosaics. The *fatale* Berthe is the unrivalled star, Manet having flattened the other characters into the background. Over the next few years, he tirelessly returned to painting Morisot's languishing face and languishing attitudes. He clearly sought something more than the merely pictorial in this strange young woman, who was always dressed soberly in Manet's favourite colours, black and white. Charming and seductive, Manet loved women rather as he loved flowers, and was always surrounded by willing models. For a while, he contented himself with portraying his wife in various poses: in *Reading* (p. 51) and the pastel *Mme Manet on a Sofa*. His *Portrait of Eva Gonzalès* (p. 45), his sole private pupil, cost him greater trouble. But his portraits of Morisot are exceptional. Most of his depictions of women have something *galant* about them, however elegant or familiar. Only those of Morisot go beyond "pure painting",

allowing something of the mystery of the human soul to transpire – along with a strong mutual attraction. The two Morisot sisters, Edma and Berthe, were not merely women of great character, they were also very talented painters. Manet met them in the Louvre, where they were copying; Fantin-Latour introduced them. Manet wrote to him: "I agree, the *demoiselles* Morisot are charming. It's tiresome they're not men." Berthe Morisot was not only Manet's muse and model, but one of the few women to establish herself among the major painters of her time.

Both sisters were infatuated with the handsome painter. Berthe received from him not lessons but advice, and became his favourite model. For all the advice, it was her influence over him that proved the greater. A full member of the Impressionist group, she convinced him in the 1870s to turn to outdoor painting and scenes of modern life, encouraging him to cast aside his outmoded *espagnolisme*, his ivory black, Van Dyck brown and burnt sienna. "There is nothing in Manet's work that I rate higher than a certain portrait of Berthe Morisot, dated 1872," wrote Paul Valéry, who married a niece of Berthe's. This is, of course, *Portrait of Berthe Morisot in a Black Hat, with Violets* (p. 52). "The potency of its blacks, the cold simplicity of the background, the brightness of the flesh, now pale, now roseate," Valéry continues, "the bizarre silhouette of the hat, which was 'all the rage' and 'young'; the disorder of the curls, bonnet-strings and ribbon that clutter the borders of her face; this face with its large eyes, whose vague fixity betokens profound distraction, offering, as it were, *a presence of absence* – all this comes together and elicits a peculiar sensation in me ... of *Poetry*, – A word that I immediately feel bound to explain to myself ... I can now say that the portrait of which I speak is a *poem.* By the strange harmony of its colours, and the dissonance of their strength; by the contrast between the futile, ephemeral detail of a contemporary hairstyle and something obscure but rather tragic in the expression of the face, Manet makes his work resonate, integrating mystery into his firm, decisive style. He combines a physical likeness of his model with the single chord appropriate to a strange person, powerfully registering the distinct and abstract charm of *Berthe Morisot.*" On a sentimental impulse, Manet also painted

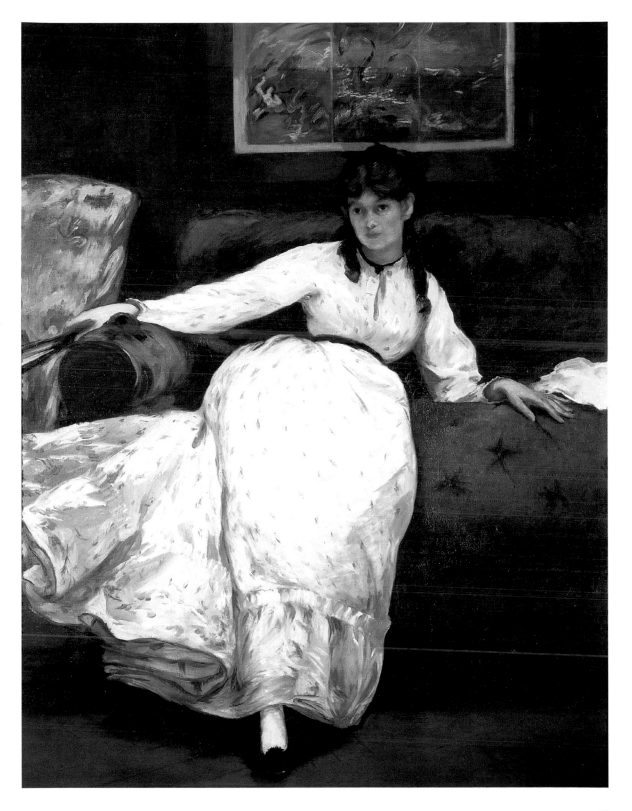

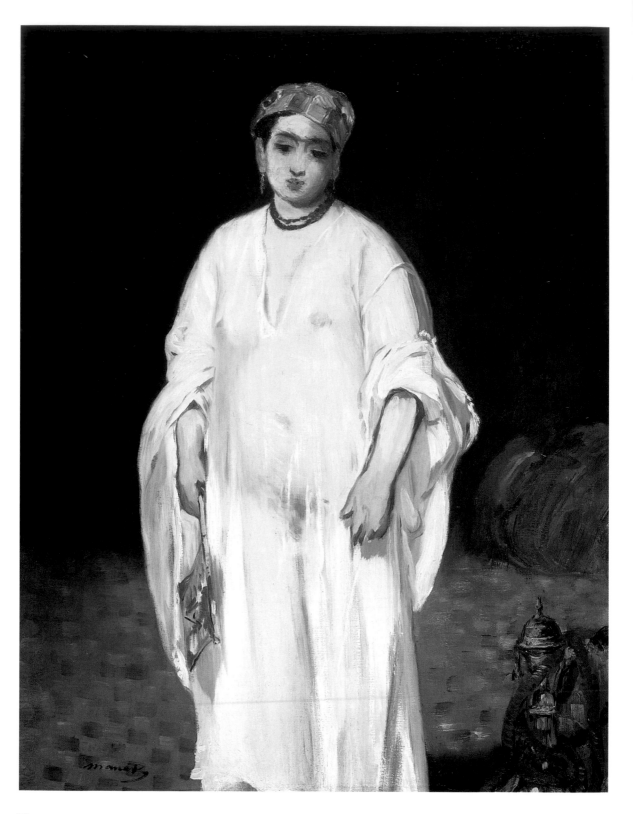

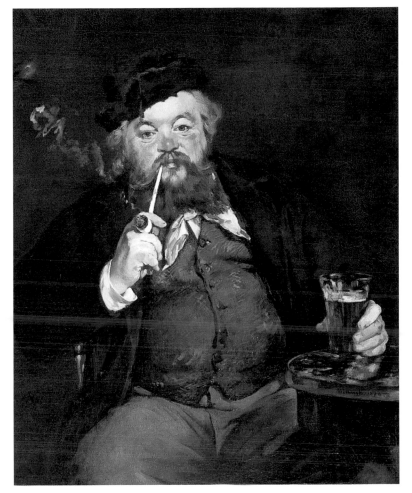

the *Bouquet of Violets* as a present for Berthe, in homage to the refinement and distinction of his exceptional model.

When, in 1869, Eva Gonzalès asked Manet for lessons, he immediately began a portrait of her. This rather disturbed his relations with Morisot. Jealousy or artistic rivalry? Berthe complained to Edma: "Manet preaches at me and is always presenting this Mlle Gonzalès as a model, she has stamina, perseverance, she knows how to carry a thing to its conclusion, while I'm a mere incompetent". Manet might well speak of perseverance, having, on Morisot's account, taken no less than forty sessions to paint Gonzalès' portrait, because he rubbed out her head every evening. Was he simply making the pleasure last, or did her face not inspire him? Morisot's did, as witness the many rapidly brushed portraits without a trace of *pentimenti*. In *Berthe Morisot with a Fan* (p. 52), or *Repose* (p. 53) he effortlessly conveys the ardent soul of the young woman, her emaciated face with its eyes darkly burning in the deep, heavily-ringed orbits. The spectators at the Salon had been right: Berthe was indeed the *femme fatale* of Symbolist mythology, courted by Fantin-Latour, Puvis de Chavannes and many other artist-suitors. She ultimately preferred Eugène Manet to his brother, though she told Edma that it was a marriage of convenience.

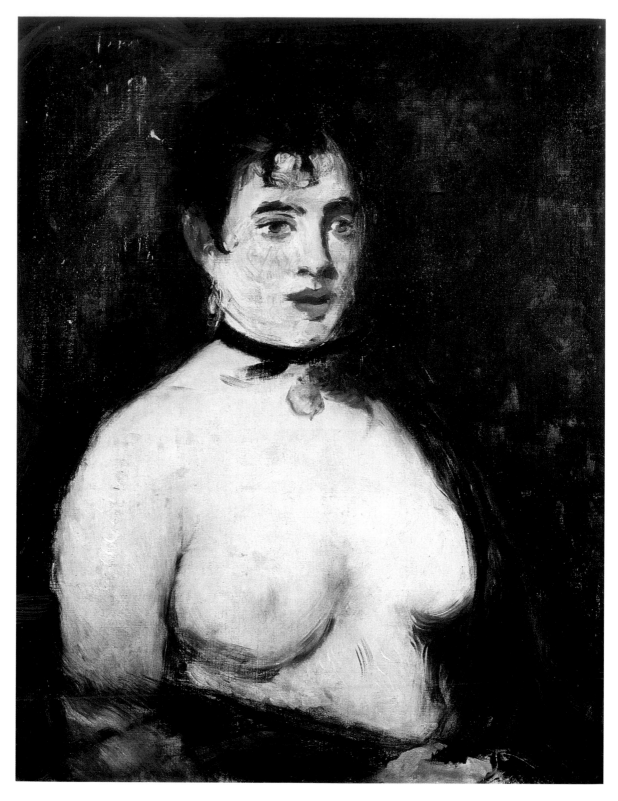

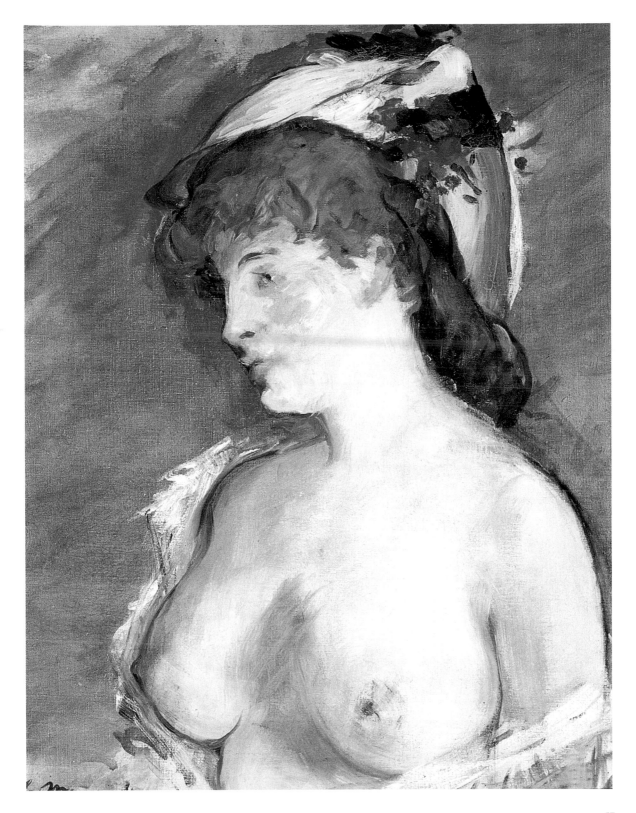

Cham: *The Salon for Entertainment*, caricature in "Le Charivari", 15 mai 1874

AT THE TOP:
Utamaro: *Young Women at the Inn – Triptych* (detail), c. 1795
Woodcut

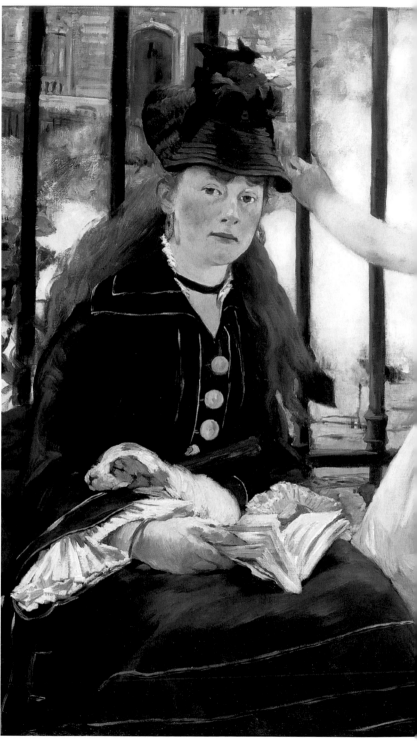

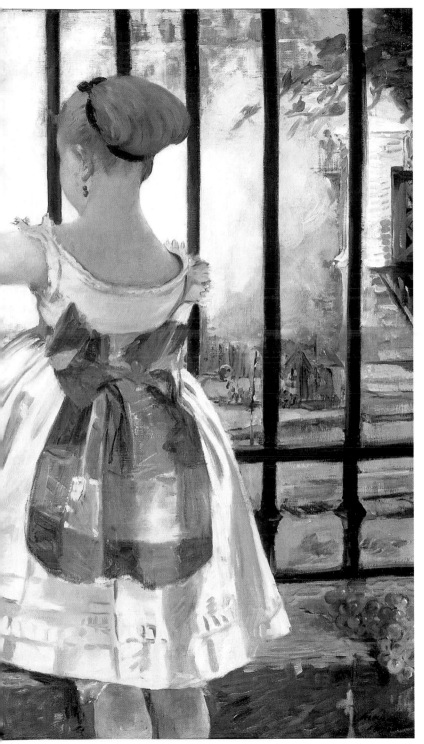

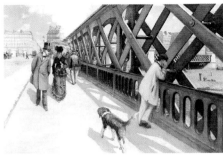

Gustave Caillebotte: *Pont de l'Europe*, 1876
Oil on canvas, 125 x 180 cm
Geneva, Musée du Petit Palais

Claude Monet: *Pont de l'Europe,
Gare Saint-Lazare*, 1877
Oil on canvas, 64 x 81 cm
Paris, Musée Marmottan

LEFT:
The Railway, 1872–1873
Oil on canvas, 93 x 114 cm
Washington (DC), National Gallery of Art, Gift
of Horace Havemeyer in memory of his mother,
Louisine W. Havemeyer

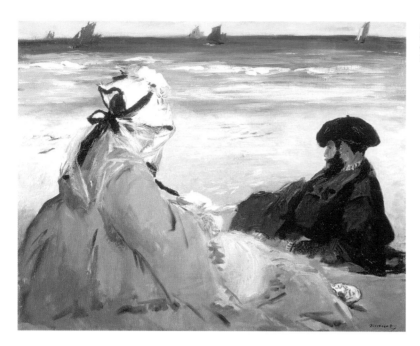

LFET:
On the Beach, 1873
Oil on canvas, 59.6 x 73.2 cm
Paris, Musée d'Orsay

The period 1868–1874 was rich in female models: *Brunette with Bare Breasts* (p. 56), *Blonde with Bare Breasts* (p. 57) and *The Sultana* all testify to Manet's excellent health. What happiness in the erotic overtones of these semi-nudes, their copious bosoms thrust out like the sculpted breasts of 18th century sphinxes! How emphatic these curves! How transparent the gauze over the *Sultana's* forms!

But perhaps the finest painting of this period is *Lunch in the Studio* (p. 50). It is a portrait of Léon Leenhoff, said to have been born to Manet and his future wife Suzanne Leenhoff before they were married. The young man was sixteen years old when thus represented, and his mother continued to present him as her younger brother. The name of Vermeer has been cited in relation to this picture, in which Manet contrived an elegant harmony between the distribution of light and the delicately contrasted yellows and blacks. Matisse saw *Lunch in the Studio* at Bernheim's in 1910, and was so struck by it that thirty-six years later he could bring details of the work to mind: "The Orientals used black as a colour, particularly the Japanese in their prints. Closer to us, there is a certain painting by Manet, I remember the black velvet jacket of the young man with the straw hat is in downright black and light".

On the Beach (p. 60) and *The Swallows* (p. 61) were products of his 1872 trip to Holland, when the impact of Frans Hals was as great a revelation as Velázquez had been in Vienna in 1856. It was Hals, more than the Impressionists, who converted Manet to painting rapidly. His brushwork became close kin to "action-painting". He now put his "black" period behind him, and embarked upon *plein-air* and long-held chords *à la* Debussy, an artist with whom Manet had undeniable spiritual affinities. Mme Manet poses on the beach, and the intense black of her bonnet with its long strings defines the harmonies of the entire painting, just as the dominant elicits the harmonies of a piece of music. These paintings epitomise Manet's new talent for seizing the eternal instant, and for embodying the notion that haunted him more than ever, that of "grand light".

PAGE 61:
The Swallows (detail), 1873
Oil on canvas, 65 x 81 cm
Zurich, Foundation E. G. Bührle Collection

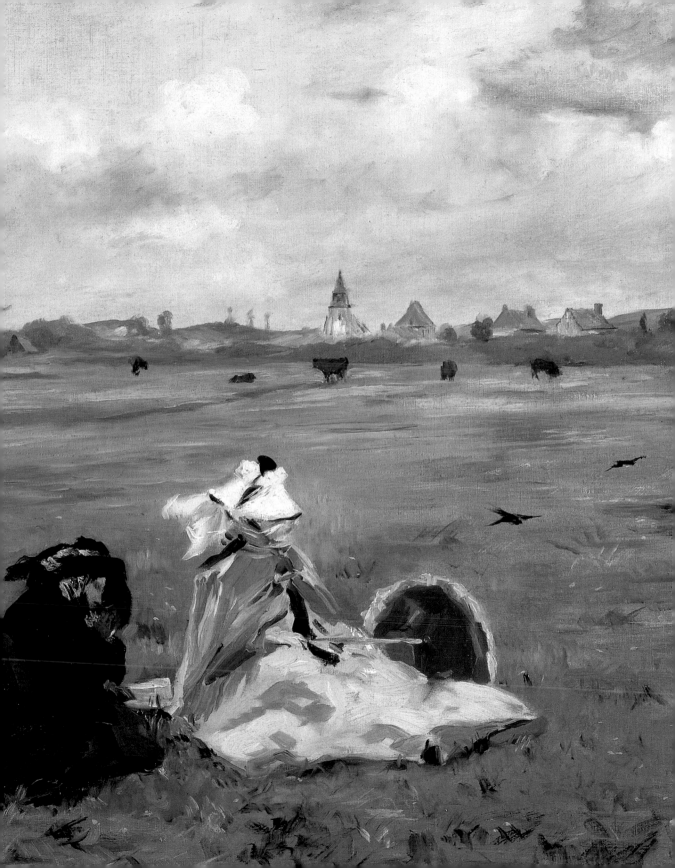

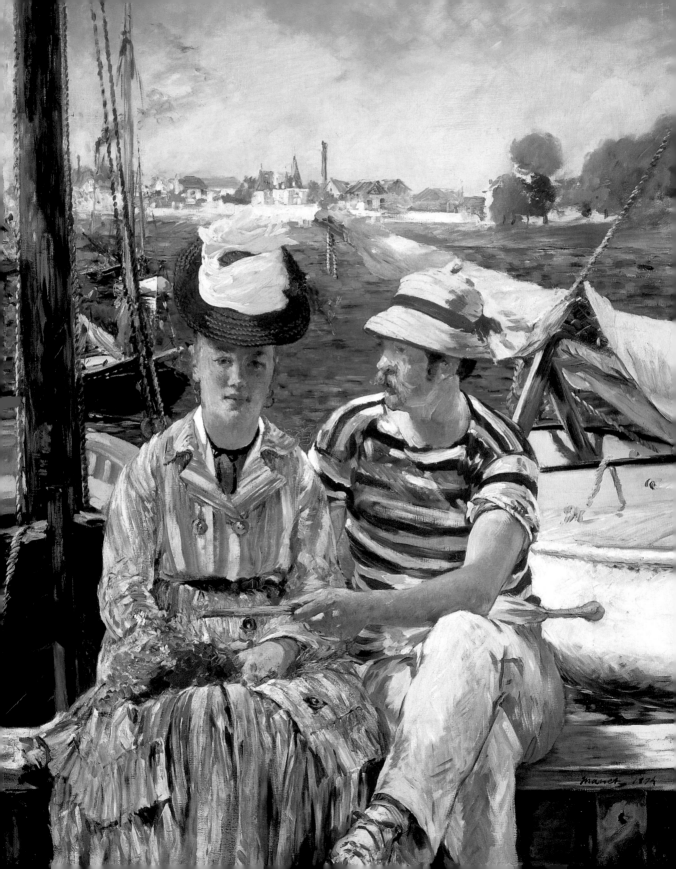

The "Boater" Years
1874–1878

"This year, Monsieur Manet has watered his beer." Albert Wolff's praise for *Le Bon Bock* (p. 55) was ironic, and perhaps expressed a hope that Manet had finally chosen conformity. Somewhat classical in manner, Hals-like in its virtuosity and relatively dark in tone, *Le Bon Bock* reassured the public at the 1873 Salon, and won a *mention honorable*. But Manet was not given to conformity, and the painting he sent to the next Salon was a positive declaration of war: *Argenteuil* (p. 62). Manet had clearly gone over to the enemy. He had, till then, avoided exhibiting with the "Monet gang" – "above all, *never* with Cézanne" – preferring to keep his works for the Salon, but could hardly have signalled more clearly his support for high-keyed *plein-air* painting. *Argenteuil* was all but a manifesto. It was also a radical transformation; this was no longer a work invented in the studio on the model of a famous museum piece. It was, on the contrary, proof positive that Manet had joined the "Monet school". Condescending to paint rowers, Manet had, in some measure, put aside his snobbism, allowing his art to rub along with the riff-raff at their pleasures. He had moved from "pure painting" to "illustration" in the Berensonian sense, and there could be no further doubt that he was a "painter of modern life". Now he attempted to compete with the man he admiringly called the "Raphael of water" on Monet's own terms. His new friend was the painter he most admired among the Impressionists. Manet threw caution to the winds, and set up his easel in the open air to paint *Claude Monet in his Floating Studio* (1874, p. 65). Monet, now living in Argenteuil, had bought his "studio-boat" second-hand so that he could spend entire days out painting on the water, accompanied by his wife. He was again on his uppers and continually appealing for aid. "I'm flat broke again," he would tell Manet, asking to borrow now fifty francs, now twenty. "I'm in the hands of a bailiff, who can make my life a misery. He's given me till midday." None of this showed in his painting, and Manet would, as usual, stump up. Antonin Proust tells us that Manet would hang his friends' pictures advantageously in his own studio, "anxious to find them buyers and forgetting his own works. During these exhibitions, he showed himself a passionate admirer of Claude Monet, whom he had portrayed in a boat; he had particular affection for that painting, and entitled it *Monet in his Studio*."

The cerulean blue of the water in *Argenteuil* (p. 62), treated, it was said, "like a wall", gave particular offense. Cézanne could hardly done worse. For the public, this work was a "red rag to a bull". Sarcasm was again the order of the day. Gaillardon was first off the mark: "We had the faintest of hopes after *Le Bon Bock*, but the bankruptcy of *The Riverside at Argenteuil* is all too evident.

Man's Head (Claude Monet), 1874–1880 (?)
Indian ink wash, 17 x 13.5 cm
Paris, Musée Marmottan

PAGE 62:
Argenteuil, 1874
Oil on canvas, 149 x 115 cm
Tournai, Musée des Beaux-Arts

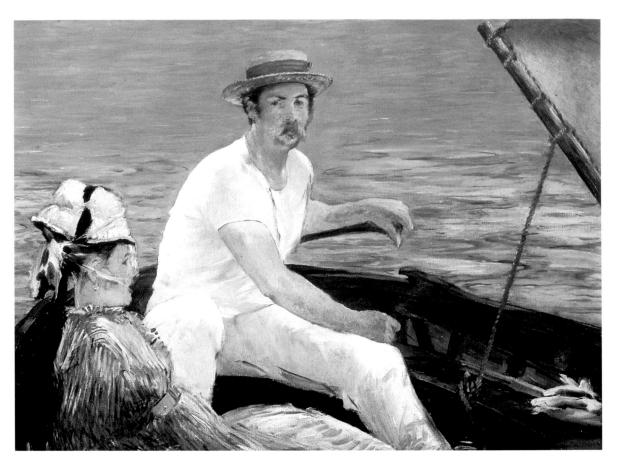

Boating, 1874
Oil on canvas, 97.2 x 130.2 cm
New York, The Metropolitan Museum of Art,
H. O. Havemeyer Collection, Bequest of
Mrs. H. O. Havemeyer

Monsieur Manet is clearly a mere eccentric." A critic called Rousseau wrote: "Argenteuil is a sticky mess on an indigo river. After twenty years, the master has reverted to student". Chesneau spoke up in Manet's defence: "Over the last three years, every year has, I feel, marked a new advance. […] He has painted the water blue. That is the principal head of complaint. But suppose the water *is* blue on certain days of bright sunlight: was he bound to paint it the traditional water-green? […] Others jeer; I applaud." *Argenteuil, Monet in his Floating Studio,* and *Boating* (p. 64), a veritable triptych, proved that Manet had at last entered the Impressionist ranks. He did so under Monet's auspices and Monet's influence. These three pictures share intense blue water, and a bold horizon-less composition, while the "layering" effect is like that of Japanese prints, which were all the rage at the time and remained one of the loves of Manet's life.

Argentueil marked a parting of the ways for Manet and Zola, who abandoned Manet as he had discarded Cézanne. Cézanne must have been delighted by the "blue walls", but Zola was exasperated, and took a high tone. Manet had remained "the enthusiastic schoolboy who always sees clearly what is happening in nature but cannot always render his impressions completely or definitively. Consequently we cannot be confident, when he sets out, where he will finish up; indeed, he may never arrive at all. He acts on intuition. When one of his paintings is successful, it is extraordinary: absolutely truthful and technically remarkable. But sometimes he loses his way – and then his paintings are imperfect and

uneven. In short, no other painter of the last fifteen years has been so subjective. Did his technique but equal his perception, he would be the great painter of the second half of the 19th century". Each to his own trade. What Zola had mistaken for technical weakness was a calculated step, an experiment prefiguring the simplification of painting practised in Manet's wake by every painter from Cézanne to Matisse. Moreover, he no longer required an Old Master to sanction the arrangement of his figures. Manet never attained Degas' virtuosity in composition, but he could now order his figures with some semblance of the natural. The time had come for him to leave his studio and open himself up to the real world.

His special friendship with Monet, and his new desire to paint from nature, came together in a picture that quickly came to figure among the legends of Impressionism: *The Monet Family in Their Garden* (p. 66). Monet took mischievous pleasure in recounting what happened that day in his Argenteuil garden. Renoir appeared, and, attracted by the atmosphere, decided to paint the same subject, *Camille Monet and her Son in Their Garden* (p. 66). It is interesting to compare the two works painted that day; we see that, though influenced by his juniors, Manet remained Manet. His painting seems both more carefully thought out and more ambitious than Renoir's, and, though he breaks new ground in his brushstrokes and variety of colours, he remains allusive, lacking the spontaneity shown by Renoir. But then, Renoir was practised at this kind of painting, whereas Manet was the beginner.

Making another attempt to emulate the "Raphael of water", Manet painted *The Grand Canal, Venice* (p. 67) during a trip to Italy. Manet was thrilled by this

PAGE 65:
Claude Monet and his Wife in his Floating Studio, 1874
Oil on canvas, 106 x 134 cm
Munich, Bayerische Staatsgemaldesammlungen, Neue Pinakothek

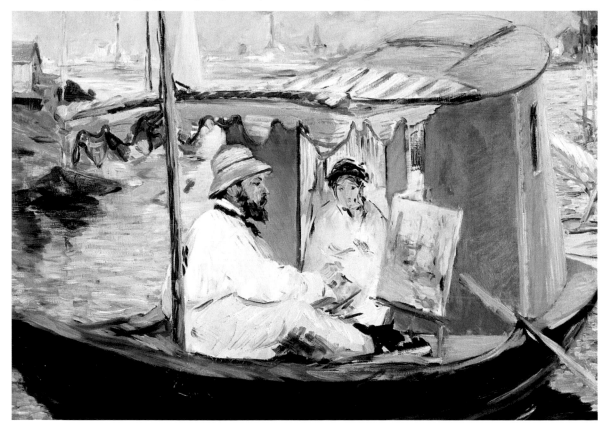

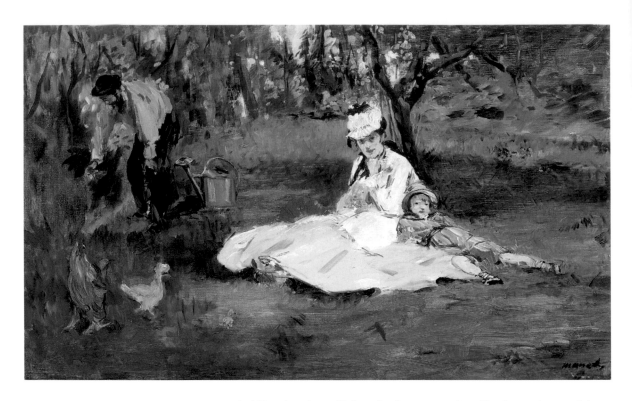

Pierre-Auguste Renoir: *Camille Monet and Her Son in Their Garden at Argenteuil*, 1874
Oil on canvas, 50.4 x 68 cm
Washington (DC), National Gallery of Art,
Ailsa Mellon Bruce Collection

AT THE TOP:
The Monet Family in Their Garden, 1874
Oil on canvas, 61 x 99.7 cm
New York, The Metropolitan Museum of Art,
Bequest of Joan Whitney Payson

PAGE 67:
The Grand Canal, Venice, 1875
Oil on canvas, 57 x 48 cm
Private collection

typical Venetian view, with its reflective waters agitated by the passing gondolas and its countless oscillations of light and shadow: "Those are champagne bottles floating bottom up … Above them, I'll have a gondola propelled by a boatman in pink shirt and orange necktie, one of those handsome lads, tanned as an Arab". In the event, the gondolier did not receive an orange necktie, no doubt because that particular splash of colour was not required.

It was again Monet and Renoir who, each in turn, influenced Manet's series of "ladies served on *canapés*". But this was a veritable interaction, with reciprocal exchanges and influences, for both Monet, in his *Mme Monet on a Sofa* (1871) and *Mme Monet Reading* (1872), and Renoir, in his *Mme Monet Lying on a Sofa* 1872, had deliberately modelled their paintings on *Olympia*, merely replacing her clothes. Manet, taking the up the theme in their wake, did the same. *Mme Manet on a Blue Couch* (p. 69) depicts his wife in full bourgeois regalia, but the arrangement of the torso and arms and even the flirtatiously-placed hand were borrowed from his "female gorilla". This time, however, Manet's picture was resolutely Impressionist, the more so for his very lively use of pastel, which allowed him still greater contrasts of texture and colour, giving his picture an intensity and bloom that oil on canvas could not match. It was a medium to which Manet often returned, and his superlative technique resulted in numerous masterpieces. The apogee of the pastel was the 18th century, and it had been relatively little practised since, confined, for the most part, to landscape, in the work of Boudin, Delacroix and Millet. Manet no doubt adopted it here under the prompting of Degas, who had made a number of successful pastel portraits, and was not shy of saying so. In a further echo of *Olympia*, transformed by Impressionist technique, Manet painted *Woman with Fans* (p. 69), which invests the pose of Renoir's *Mme Monet Lying on a Sofa* with a dazzling virtuosity. The

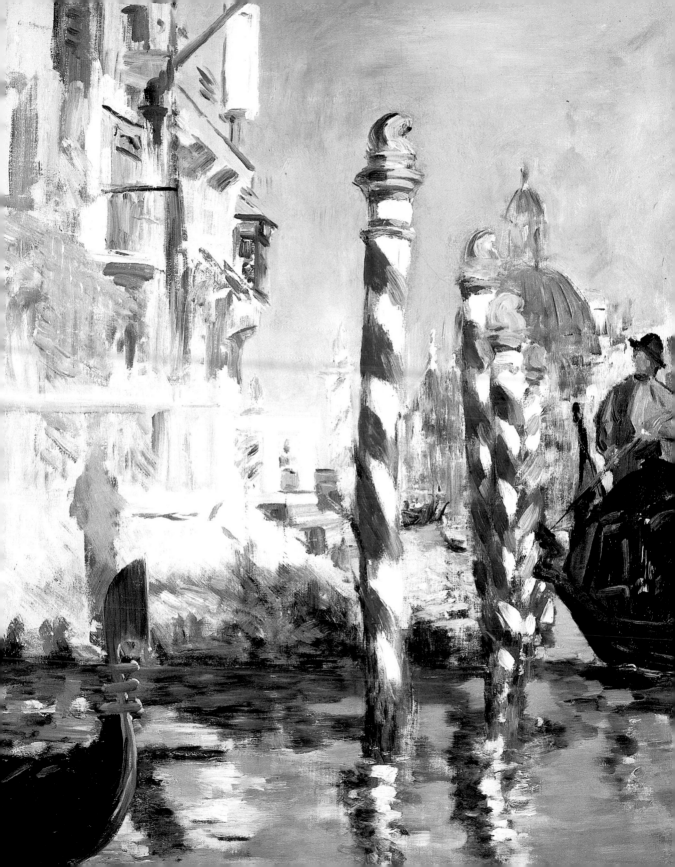

portrait is of Nina de Callias, who, though not exactly a *demi-mondaine* – her comfortable income lifted her out of this category – had a great many lovers, from Villiers de l'Isle-Adam to Charles Cros and Bazire, all writers and artists, and most of them living in noble destitution. De Callias held one of the most brilliant literary and artistic salons in Paris, where poets – the Parnassians and the earliest Symbolists – rubbed shoulders with musicians and painters. De Callias was herself an excellent pianist and composer. The starving could attend and be sure of a good meal. Manet, introduced to this rather rackety milieu by Charles Cros, enjoyed himself hugely and became a regular.

Baudelaire was dead, and Zola had lost the plot: enter Mallarmé. Few artists could, like Manet, boast friends of such genius, or champions of such extraordinary stature. The painter probably met the poet at Nina's; he was ten years Manet's junior. They were both entranced, and their friendship immediately became a close one. Almost every day, Mallarmé, on his way home from teaching English at the Lycée Fontane (now Lycée Condorcet), would stop off at Manet's studio to chat with him and meet his little circle, which was no less distinguished than Nina's, though more selective. The contacts he made there were vital ones, drawing him into the entire Impressionist milieu; he made close friendships

Madame Manet on a Blue Sofa, 1874
Pastel on paper backed with canvas, 65 x 61 cm
Paris, Musée du Louvre, Cabinet des Dessins

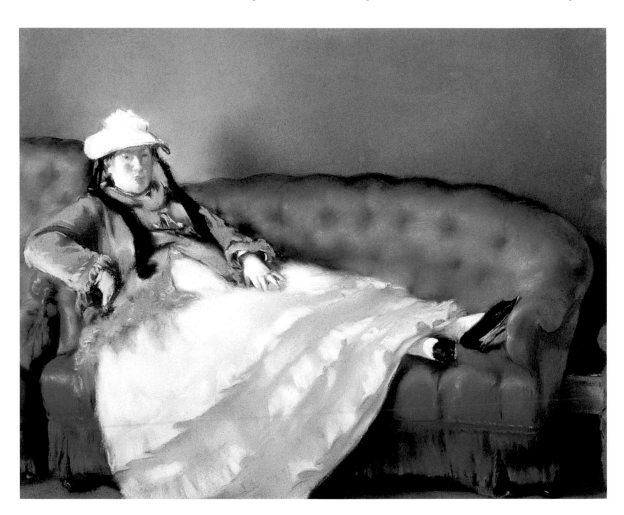

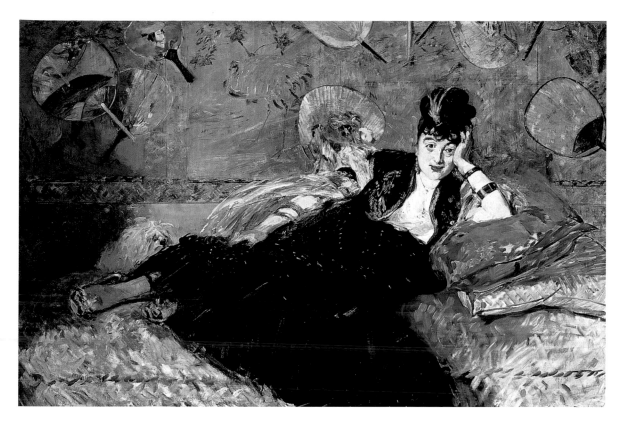

with Degas and Renoir. And it was at Manet's that Mallarmé first met the actress Méry Laurent, of whom Manet made seven pastel portraits, including *Autumn*. This extraordinary woman was to become Mallarmé's great love, though she remained faithful to the memory of Manet, marking the anniversary of his death by laying lilac on his grave. For Manet and subsequently Mallarmé she was both Muse and lover. She was "kept" first by Marshal Canrobert and then by an American, Dr. Evans, the influential dentist to the Emperor. The benefit of such "protection" was a relative freedom, and she loved to surround herself with artists and writers. She also had a liaison with François Coppée, and in the last years of her life enjoyed a tender attachment to the gay composer Reynaldo Hahn. Marcel Proust came to know her through Hahn, and, fascinated by her lifestyle, environment and wardrobe, took her as one of the models for Odette Swann in *À la recherche du temps perdu*. The name of Méry Laurent evokes not merely the atmosphere that poet and painter so loved, but an entire literary and artistic epoch of extraordinary richness. Manet was enchanted by Laurent's elegance. He spoke of a fur-lined coat, "a *pelisse* that she had had made at Worth's. Ah! what a *pelisse*, my friend, tawny-brown with a lining in old gold … When this garment is worn out, you must hand it over. She has promised it to me. It will make a stunning background for things I dream of doing". And he did indeed paint a superb portrait of her, *Woman in a Fur Coat*. Mallarmé, meanwhile, wrote her (among many other poems) the following lines, which she had engraved above the door of her town house: "Open to laughter-flow/Like water around her,/No bitterness to her,/Scent of heady roses/In gardens royal Méry is".

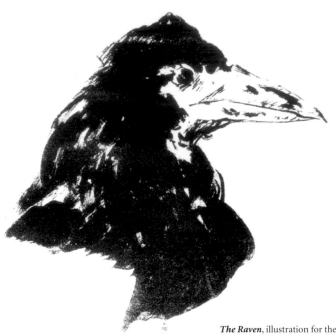

The Raven, illustration for the cover of
Edgar Allan Poe's poem, translated by
Stéphane Mallarmé, 1875

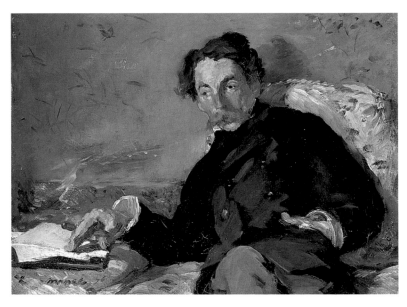

ABOVE:
Portrait of Stéphane Mallarmé, 1876
Oil on canvas, 27 x 36 cm
Paris, Musée d'Orsay

RIGHT:
Once upon a Midnight Dreary, illustration for
the poem "The Raven" by Edgar Allan Poe,
translated by Stéphane Mallarmé, 1875

Before the Mirror, 1876–1877
Oil on canvas, 92.1 x 71.4 cm
New York, Solomon R. Guggenheim Museum,
Thannhauser Collection, Gift of Justin K.
Thannhauser

Indeed, another common point between the "man-about-town" painter and the provincial-born poet was their fascination with women and women's fashions. Manet's elegance, not to say coquetry, was notorious. As for Mallarmé, he famously wrote a fashion-column under the astonishing pseudonym of *Miss Satin*, to Manet's great amusement; Manet had, after all, been something of a tutor to Mallarmé in the matter of Parisian refinement.

On 27 May 1875, Mallarmé received a laconic note from Manet: "Dear Friend, come to the studio this evening at 5 to sign your copies". The volume in question was Edgar Allan Poe's *Corbeau* (*The Raven*). The poem had already been translated by Baudelaire, but Mallarmé undertook a new translation and asked Manet to illustrate it. Introducing himself to the intrepid publisher Lesclide, Mallarmé told him he was "a bibliophile run mad, finicky, I must confess, but sure of coming to an understanding with you to make something very special". The refined tastes of poet and painter were indeed exorbitant, and Lesclide declared himself "very worried about the black silk that you intend to put on the back of the box". Manet, meanwhile, was demanding "parchment, paper of a tender green or yellow, close to the colour of the cover". Used for the poster, the profile head of the Raven (p. 70) is a detail from Manet's first illustration (pp. 70–71). It amply demonstrates the power and precision of Manet's drawings, his concern for detail, and the humour that he could never resist inscribing into his work. Thus Poe's first verse describes the poem's speaker, "once upon a midnight dreary" pondering over "many a quaint and curious volume of forgotten lore", when he thinks he hears "some visitor … tapping at his chamber door". It is, of course, the Raven. But the poet depicted is none other than Mallarmé, and, for good measure Manet places on a chair a cane and top hat that can only be his own. According to Mondor and Jean Aubry, the book was guaranteed to fail: "the voluminous proportions …, the illustrations by Édouard Manet, an artist still controversial in 1875, the singularity (for most readers) of Edgar Allan Poe's poem, and Mallarmé's own lack of reputation … combined to scare off possible buyers of the work, though it was published in a very limited edition (240 copies) and at a price that today seems very reasonable". The poster announced: "Five drawings by Manet, illustrations on Holland or China paper 25 francs, duplicate prints on Holland or China paper 35 francs, illustrated pasteboard 5 francs extra." A small circle of initiates was ravished, but elsewhere the work and its authors were roundly condemned. Mr O'Shaugnessy's copy, signed and dedicated by both authors, was inherited by the Pre-Raphaelite painter and poet Dante Gabriel Rossetti: "By the bye, my own moment of O'S is a huge folio of lithographed sketches after *The Raven*, by a French idiot named Manet, who certainly must be the greatest and most conceited ass that ever lived. A copy should be bought for every hypochondriac ward in lunatic asylums. To view it without a guffaw is impossible." Philistine son of Albion! Let his "forgotten lore" be repeated "Nevermore!" Manet and Mallarmé were unabashed by this reception. An exquisite edition of Mallarmé's *L'Après-midi d'un faune*, illustrated with Manet woodcuts (pp. 94–95), was successfully published by Derenne in April 1876.

Some fifteen years after *Olympia*, under the auspices – at last combined – of Naturalism and Impressionism, Manet returned to the theme of the courtesan in *Nana* (p. 73). But there is no reference here to the past. If anything Manet refers to the future, given that the subject and title suggest a reference to Zola's novel of the same name. That work was not in fact begun until a year and a half later; its serialisation in *Le Voltaire* started in October 1879. But the theme was in the air at the time. Perhaps the two old friends had discussed it at some stage, and

PAGE 73:
Nana, 1877
Oil on canvas, 154 x 115 cm
Hamburg, Kunsthalle

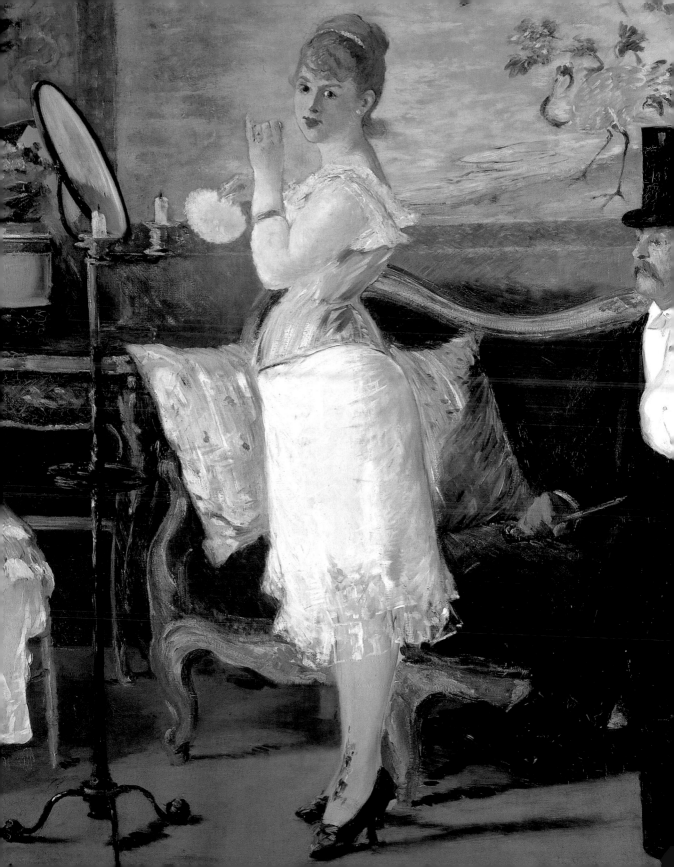

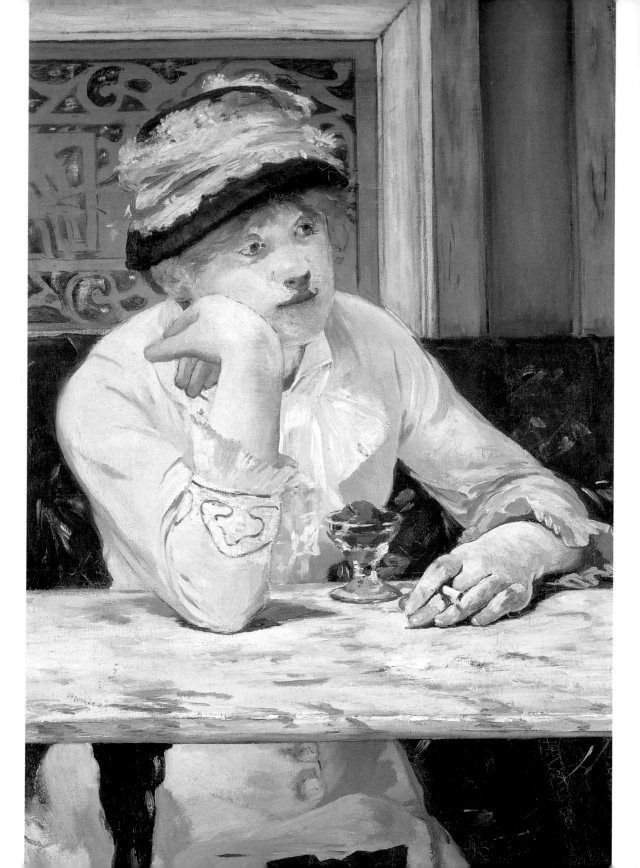

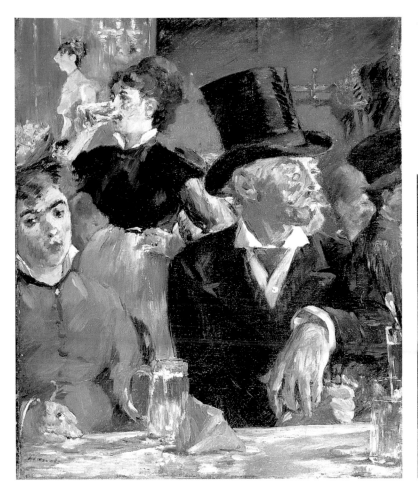

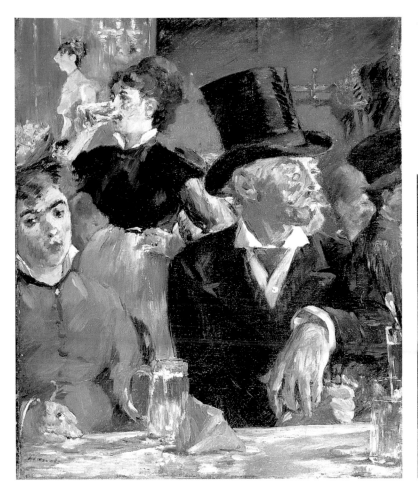

At the Café, 1878
Oil on canvas, 47.5 x 39.2 cm
Baltimore (MD), The Walters Art Gallery

Edgar Degas: *L'Absinthe*, 1875–1876
Oil on canvas, 92 x 68 cm
Paris, Musée d'Orsay

Manet had surely read *L'Assommoir* (1877), in which Nana makes her first appearance. Who influenced whom? Félicien Champsaur, a friend of both men, considered the matter: "When Monsieur Zola's novel *L'Assommoir* appeared, following the impression given in this work, Monsieur Manet painted Nana at eighteen years of age, full-grown and already a tart. She is essentially Parisian, a woman who has grown a little plump with well-being, slender-waisted and seductive if not elegant … Since then Nana has grown. In the mind of her creator, Monsieur Zola, she has mutated into a proud, opulent, buxom blonde, with a peasant-like bloom, who no longer resembles Monsieur Manet's Nana. Who was right? The Impressionist or the Naturalist?" One thing is certain. The skinny little Baudelairian prostitute *Olympia* had few attractions for Renoir, but when he saw *Nana*, her sturdy haunches outlined by her petticoat, her well-built form bundled into her bright blue corset and her legs enticingly sheathed in embroidered blue stockings, he was of quite another mind; this was a woman entirely to his taste. Within the picture too, the balance of power had changed. Nana is not receiving a client, but mischievously testing the patience of a protector. The latter's presence in the painting – he wears a hint of annoyance – is very much in the Degas manner, cut in half at the painter's pleasure. Manet is witty as ever: Nana seems to be wondering "How can men be so stupid?" The bird visible

PAGE 74:
The Plum, 1878
Oil on canvas, 73.6 x 50.2 cm
Washington (DC), National Gallery of Art,
Mr. and Mrs. Paul Mellon Collection

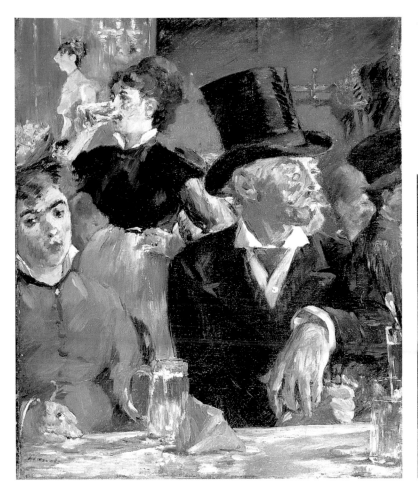

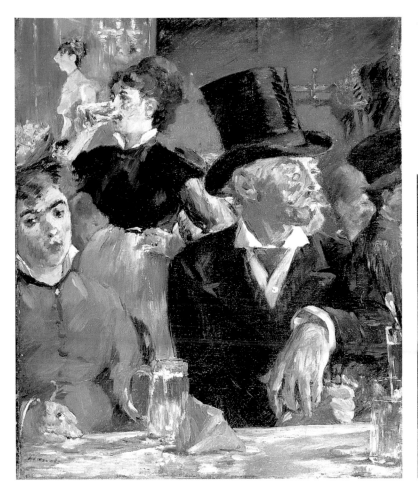

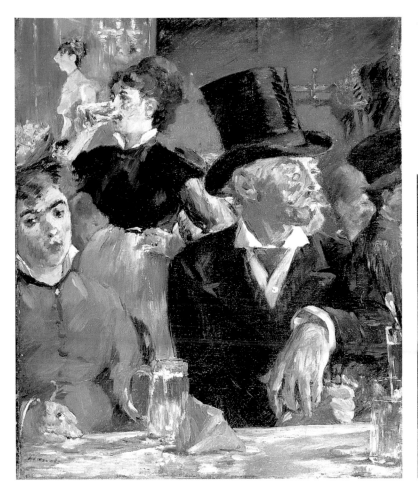

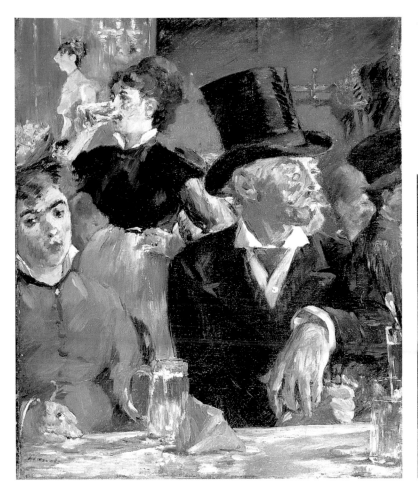

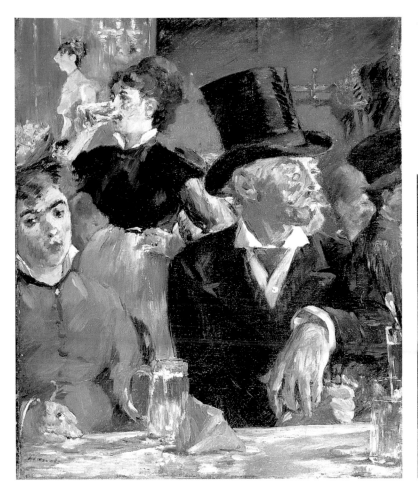

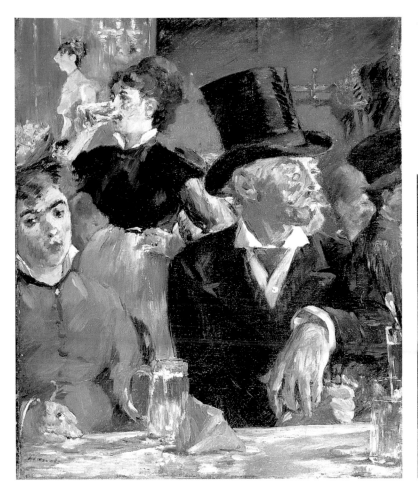

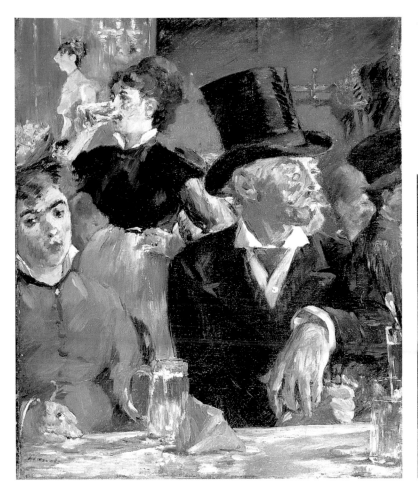

The Hackney Carriage, 1878
Graphite, 16.8 x 13 cm
Paris, Musée du Louvre, Cabinet des Dessins

in the ornamental background is perhaps a crane, the French for which, *grue*, at the time signified a prostitute. The allusion would no doubt have seemed in deplorable taste to certain of Manet's spectators, but the painter of the "black cat" was quite capable of such things, as the *Portrait of Nina Callias* shows. For good measure – and to supplement the iconography of the corset, popularised by saucy magazines such as *La Vie Parisienne* – Manet painted a second and still plumper Nana, undoing her corset *Before the Mirror* (p. 72). Never before had Manet displayed such a casual virtuosity, made such free play with hatching, nor presented a picture so overtly sketchy as this; we are reminded not of Velázquez but of Degas. The Salon, the occasion of Huysmans' paean, rejected both paintings. But when they were exhibited in a boulevard des Capucines shop-window, they almost caused a riot, with one part of the crowd indignant as ever, and the other full of enthusiasm. This ensured their success. In the press, Marthold compared Manet's methods with those of Flaubert, and more especially Balzac: "For a work to endure, the first condition is that *be of its own time*; […] the modernists who have rendered their epoch eternal can be counted on the fingers of one hand […] This century numbers but two of them as yet: the first is Balzac, and the second is Manet."

According to Tabarant, *Nana* (p. 73) was the first painting in "a Naturalist series"; Manet intended to depict the "most striking characters" of early Third-Republic Paris, at a time when "life was becoming easy, taking on a happy countenance and an acid savour of debauch. Vulgar music-halls were all the rage, from Montmartre to Point-du-Jour. Everywhere, sexual opportunity smiled." *The Plum* (p. 74) belongs to this series. The prostitute that Degas had painted two years before in *L'Absinthe* (p. 75) was a picture of ravaged depravity. Not so Manet's prostitute, who, like most of the woman he portrayed, is quite different from Degas' haggard model; her ethereal, dreamy air almost entirely removes her from the context she evokes. Lost in melancholy daydreams, she neither lights her cigarette nor touches her brandy-soaked plum. This was the first of Manet's many café scenes, which followed, like so many *bodegones* of modern life: *Café-Concert* (p. 75), *The Waitress* (p. 78), and soon his absolute masterpiece – in a sense his testament – the *Bar at the Folies-Bergère* (pp. 88/89).

From 1872 to 1878, Manet occupied a studio in rue de Saint-Pétersbourg (today rue de Leningrad), whose windows gave onto rue Mosnier (now rue de Berne), described in Zola's *Nana* as a street of unsavoury reputation. He made use of his vantage-point to paint a series of pictures, seen by Zola and perhaps put to use in certain passages of *Nana*. Monet and Renoir were the contemporary specialists in urban landscape, but their "views of Paris" dwelt above all on the modernity of the prospect. Manet, like Baudelaire, detested the country-side, and found landscapes futile unless animated by some justificatory "event". When he painted a view of the Trocadéro, it was on the occasion of the *World Fair* (p. 36), his seascape was justified by the *Combat of the "Kearsarge" and the "Alabama"* (p. 31) and he painted the *Grand Canal* (p. 67) as a souvenir of his trip to Venice. When he painted *Rue Mosnier with Pavers* (p. 77), what interested him was not the street but the pavers; the "event" was Haussman's urban reforms, which had turned Paris in its entirety into a building-site. But his eye was also taken, just as Zola's might have been, by the unloading of the removals van, the hackney cab betraying a gentleman's amorous visit, and the handsome red placard advertising "children's made-to-measure clothing in the taste of the day".

PAGE 77:
Rue Mosnier with Pavers (detail), 1878
Oil on canvas, 64 x 80 cm
Private collection

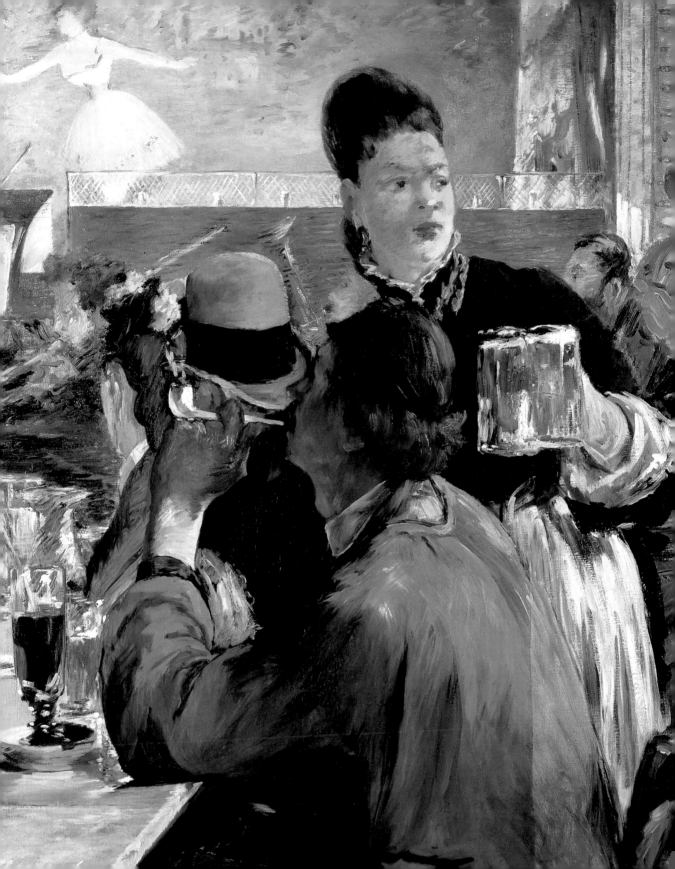

"Greater than we thought …"
1879–1883

"In every least word she uttered, one heard the profound love she felt for her terrible, charming husband," says De Nittis of Suzanne Manet. One day, he was following a pretty girl, a slender young flirt. All of a sudden his wife appeared, and laughingly announced "This time, I've caught you at it". "Well, goodness!" he replied, "That's strange, I thought it was you!" But Mme Manet, placid Dutchwoman as she was, was no Parisian sylph, inclining rather to the substantial. Humour and affection were the guiding lights of their married life: a great man, Suzanne felt, must be forgiven for occasionally straying … In Manet's last years, a rustling swarm of adorable young women gathered around the easel of the now fashionable painter. His new studio at 77 rue d'Amsterdam was *the* place to be seen, and society women flocked there to display the latest creations of Worth. These "fashion-plates" competed to model for him. There were *cocottes* like Valtesse de la Bigne, actresses like Jeanne de Marcy, and young women about town like Isabelle Lemonnier (p. 79). He was a much-loved man; his admirers included loyal friends like Berthe Morisot, now married to his brother Eugène, models, love-struck actresses, and *demi-mondaines* such as Méry Laurent, who kept a protective eye on him. Nothing, it seemed, was lacking; famous and famously charming, he was working harder than ever. The glory was deceptive. Manet became conscious of pains in his left foot; they were symptoms of locomotor ataxia, a manifestation of tertiary syphilis, that virulent scourge of a promiscuous epoch. Baudelaire and Manet were among its many illustrious victims, which later included Maupassant and Nietzsche.

Manet painted this circle of women in all states of dress and undress: nude, in translucent veils, in their morning *déshabillé* or dressed from head to foot for society or seduction. He recorded every detail of their modish splendour and exotic millinery, revelling in the dash bestowed on fine cheekbones by the ornate hairstyles of the time. The Impressionists, Monet and Degas in particular, had helped relieve him of his painterly inhibitions, and from 1876 to his death in 1883 he became a perfect virtuoso. It is as if he improvised a new technique for every new picture, hatching for effects of vibrant light or setting the surface alive with a torrent of brush-strokes. He was painting now in the shadow of mortality, and his strokes were the more cursory and impatient. His nudes grew increasingly sketchy. To paint these dazzling ephemera, his virtuosity grew ever more protean, varying from a milky impasto devoid of *pentimenti* to the descriptive flourish of pastel. Manet focused on the fugitive grace of his women models, lavishing on them the fruits of his amorous gaze. In *Blonde with Bare Breasts* (p. 57) or *In the Tub* (p. 82), his brush caresses the canvas. The canvas is barely covered by the

Woman in Blue Dress – Portrait of Isabelle Lemonnier with Parasol, 1880
Watercolour, 20 x 12.5 cm
Paris, Musée du Louvre, Cabinet des Dessins
Manet included watercolour illustrations in letters to Madame Guillemet, Méry Laurent, and Isabelle Lemonnier, the destinee of this one.

PAGE 78:
Corner of a Café-Concert, 1879
Oil on canvas, 98 x 79 cm
London, The National Gallery

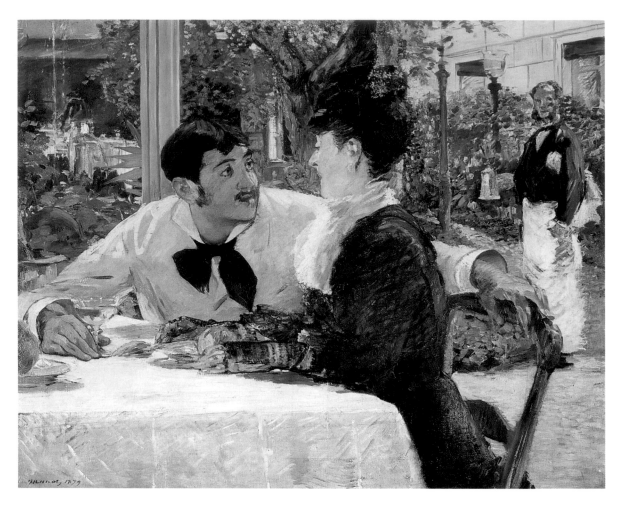

Chez le père Lathuille, 1879
Oil on canvas, 92 x 112 cm
Tournai, Musée des Beaux-Arts

thick oils spread here and there on the surface, while highlights of white or red-ochre render the flesh-tones of the nude. They were painted, in the expression of the time, *du coup*, "all in one go", in inspired, amorous improvisation. They have consequently shown splendid resistance to aging, while other works over which Manet laboured, tirelessly retouching the details of a face, have begun to crack.

Manet was now a fulfilled man. The anxieties and *pentimenti* visible in his earlier works were now a thing of the past. *Woman in the Tub* shows Méry Laurent, whose devotion was unfailing. Though a kept woman of considerable means, she still loved to undress and pose for her lover. In this she was merely returning to her earliest successes, for in her early career she had trodden the Parisian theatres without a shred of clothing to her name, as she told Henri de Régnier, a close friend of hers during the 1890s. He made a poem of her story, "To A Lady who Knew Manet": "Madame, our encounter/Was late, you were no longer/The nude bather Manet showed/In the zinc tub posed/While rainbow colours flowed/From the skylight-rose/Over reams of flowing chintz,/And your shoulders were rinsed/By the sponge his hand proffered./On the canvas is evinced/In the portraits that he made/All the beauty that you offered/To his brush's accolade". The two portraits were *In the Tub* and *Woman Fastening Her*

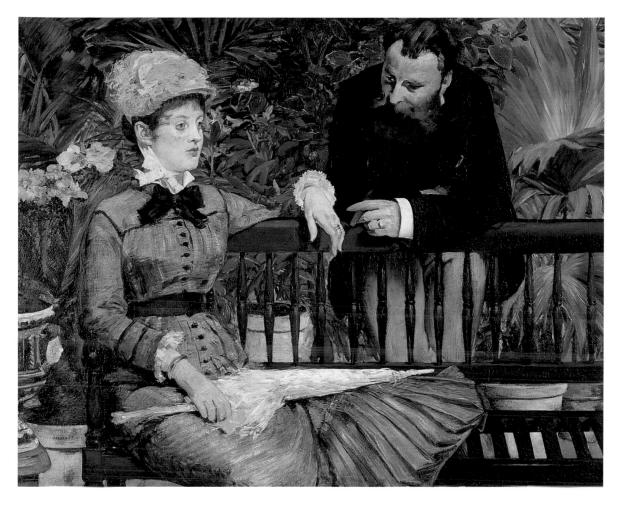

In the Conservatory, 1879
Oil on canvas, 115 x 150 cm
Berlin, Staatliche Museen Preussischer
Kulturbesitz, Nationalgalerie

Garter (p. 83), and they are among the finest examples of this almost domestic theme, displaying all the characteristics of Manet's mature art: his spontaneity, freshness and generosity combined with rigorous composition, in which lines and curves stand out against a still life of mirror, dressing table, flower-printed cretonne and wallpaper.

For Manet, his intimate life was also a subject for painting. Following in his wake, the other Impressionists would, each in their turn, cross the threshold of private life, an area of art in which the Japanese were undisputed masters. There is no voyeurism in Manet. His subject is the female body wholly focused on itself, and in depicting it, he extended the realm of his art. Here, stripped of artifice, a woman meditates conquest as she stoops to rinse. Society woman is caught pre-society. But though the subject, in Manet, no longer had the same importance, his sensuality transpires as strongly as his affection. "Drawing is not form," he said, "but the way forms are seen", and "Even with nature, composition is required". These maxims specify Manet's divergence from the Impressionist doctrine of fidelity to nature. They also distinguish him from Degas, who, some ten years later, began his astonishing series of women washing, returning to the theme of the bathtub in sophisticated overhead and *japoniste* perspectives.

LEFT:
The Bath, 1878–1879
Pastel on cardboard, 55 x 45 cm
Paris, Musée du Louvre, Cabinet des Dessins

To paint the ablutions of this series, Degas turned himself into a veritable voyeur, peering through keyholes or assuming a quasi-entomological objectivity. Neither beauty nor desire concerned him, and he had no sympathy for his models. He said of his dancers: "They are my tools". In relation to Degas and the "hint of ugliness" inherent in his foreshortening viewpoints, critics have spoken of cynicism, cruelty and misogyny. This was Degas' way of stepping beyond realism and Naturalism in the direction of modern art, and it has nothing in common with Manet's fond gaze. The affection that Manet brought to his scenes of *toilette intime* has no equivalent until the work of Bonnard.

Manet's life was increasingly at one with his work. What he liked, almost as much as the company of beautiful women – preferably those in love with him – was the atmosphere of cafes and brasseries. A city-dweller born and bred, he relaxed after work in the café as others might in the garden. There he met his friends. Many of the memoirs of his habits and lifestyle were written by those who frequented him in the Café Guerbois, the Tortoni or the Nouvelle-Athènes. In his *Waitress* (p. 78), Manet continued the Naturalist series that had taken him from *Nana*, the young courtesan, to *The Plum*, in which the woman's melancholy is evident. Over and beyond its anecdotal value, the painting's sheer technical exuberance impresses. Manet creates his figures and details the scene in broad

PAGE 83:
Woman Fastening her Garter (The Toilet), 1879
Pastel, 53 x 44 cm
Copenhagen, Ordrupgaard

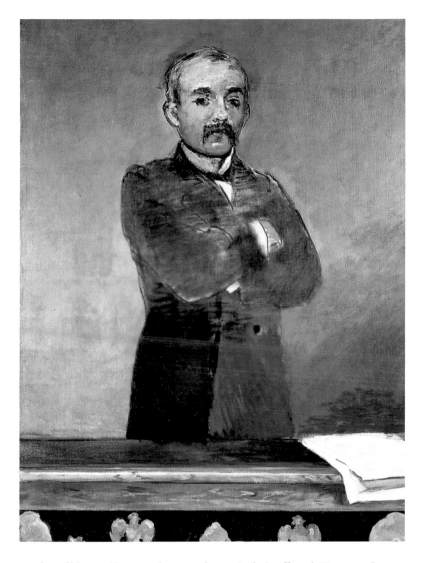

strokes of blue and brown, a harmony he particularly affected. He was no longer tormented by questions of organisation. Composition came to him spontaneously now, with all the modernity of the photographic instant; no trace of clumsiness remains. He was, in short, having fun. Duret tells us that Manet had noted "the movement of the waitresses, who, when they placed a mug of beer in front of the customer with the one hand, could keep several other mugs upright in the other, without spillage [...] Manet asked the one who seemed to him the most expert in the whole café [to pose for him]". She, in turn, insisted on having her protector with her. Manet put him to work modelling the young man smoking in the foreground. The young woman performed her balancing trick with the beer while Manet put his magic to work on the canvas.

Manet's humour combines with his love of pretty women and their clothes in two paintings that both, in their way, hark back to *Balcony* (p. 46, 1875). There is a certain kinship to *Monsieur and Madame Guillemet in the Conservatory* (p. 81) and *Chez le père Lathuille* (p. 80). Manet remained a dandy, and could not resist

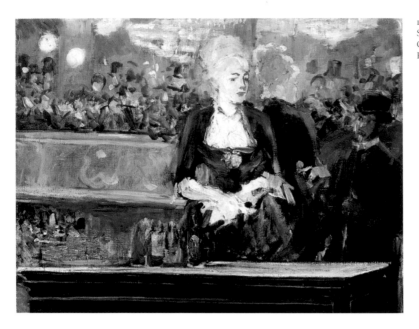

LEFT:
Study for *A Bar at the Folies-Bergère*, 1881
Oil on canvas, 47 x 56 cm
Private collection (London, Pyms Gallery)

once in a while returning to his first love, *fin-de-siècle* Paris life. The Guillemets were close friends of his and, to Manet's great pleasure, ran a *haute couture* salon in the faubourg Saint-Honoré.

Humour is also present in *Chez le père Lathuille*, since the subject Manet had chosen was a gigolo of prepossessing air seducing a much older woman under the ironic eye of the waiter. Manet toiled over the palm trees of *Conservatory*, which look slightly tinny. *Chez le père Lathuille* is no less descriptive, but here the impasto hatching fills the painting with light. The composition is admirably free; the staging of figures held no further mysteries for Manet. This is one of the high points of his entire oeuvre, a product of the blossoming plenitude of his talent. The work was painted at the restaurant Du père Lathuille, next to the Guerbois, and features the owner's son as the gigolo. He was supposed to pose in uniform, but Manet preferred him less formal. The woman was Mlle Judith French, a relative of Offenbach. Manet does wonders with their costumes, feasting himself on the details. "Yet" said Edmond Bazire, "people made fun of the woman at her lunch. People made fun of the hairstyle of her young friend. What then? Should Manet have painted a pompadour and a garde-française?"

One might have expected that Manet, surrounded by a swarm of adoring women, would indulge himself, and become a little macho. But his criteria in painting remained strictly artistic. He claimed that in portraying men it was their character that he sought to express; with women, he wished merely to record their ephemeral beauty. He looked for truth in men, and for attraction in women. His women-subjects could hardly complain of this; it was the finest homage he could pay, and in any case the one to which they were most sensitive. Germain Bazin verified this in his comparison of Manet's *Woman in Horse-Riding Costume* (p. 84) with the unfinished *Clemenceau at the Tribune* (p. 85). The woman belonged to Manet's "Naturalist series"; the image of a modern Parisian woman, she has performed the rituals of fashion obligatory before appearing in public. The contrast with the Clemenceau portrait is clear. The politician had little time to pose; but, sketching in face, torso and crossed arms with lapidary

PAGE 87:
Study of the model for the waitress in
A Bar at the Folies-Bergère (detail), 1881
Pastel, 54 x 34 cm
Dijon, Musée des Beaux-Arts

PAGE 88/89:
A Bar at the Folies-Bergère, 1881–1882
Oil on canvas, 96 x 130 cm
London, Courtauld Gallery

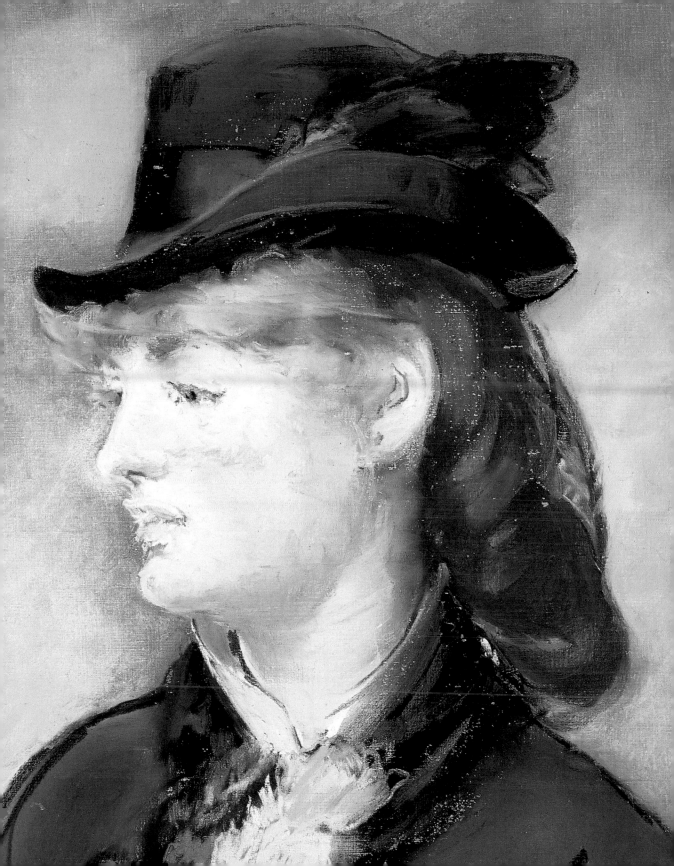

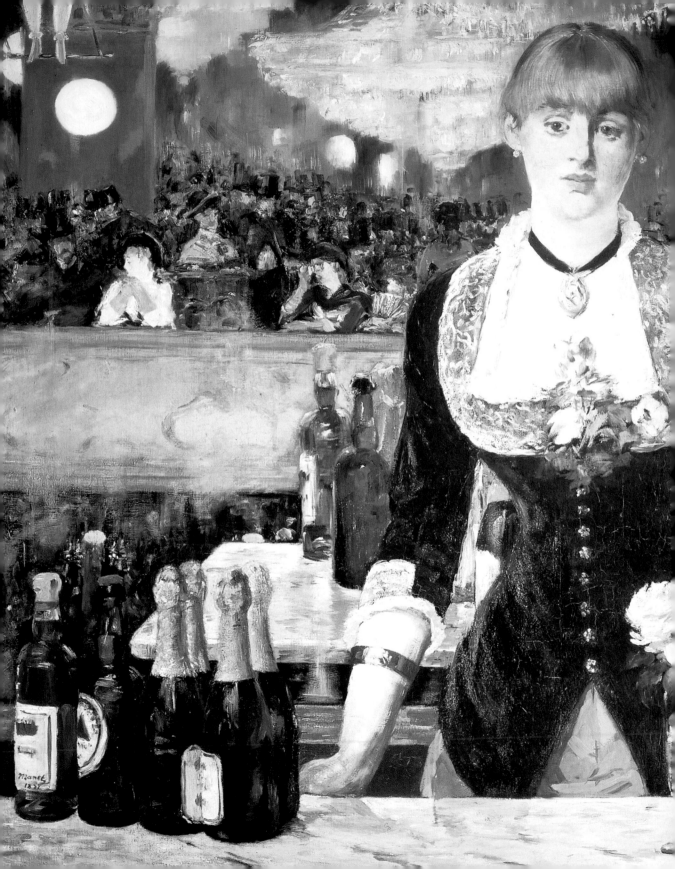

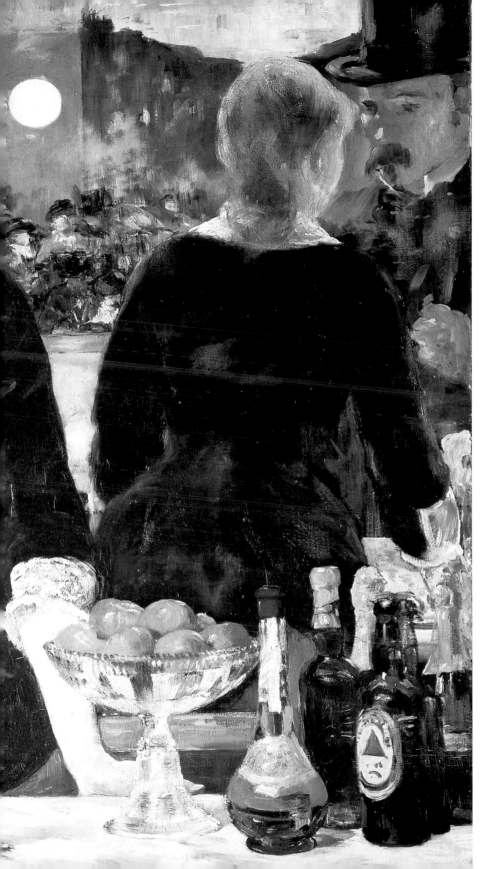

MANET

ET MANEBIT

Félix Braquemond: Édouard Manet's ex-libris,
1874.

indications and a *japoniste* outline, Manet contrived to give physical expression
to the hectoring energy and taunting humour of the "Tiger" – the man credited
by France with winning the First World War.

Bazin said of Manet's women: "One might think that, for him, they have no
soul. Only Berthe [Morisot] seems equipped with one. It is wrong to tax Manet
with superficiality. He shows himself a true society portraitist. The suggestion
that a woman should be painted like a man is to show complete incomprehen-
sion of the portraiture of women, and indeed of women *simpliciter*; the mas-
culine portrait must be a study of character, obtained by accentuating certain
features, whereas to paint a woman in her unvarnished reality is a social incon-
gruity – worse, a form of insolence, perhaps, indeed, a lie. […] It is understood
that they are not made for the gaze of truth. On this object, only the gaze of love
should rest". When he painted a woman, Manet, as admirer or lover, confined
himself to "the exterior". In portraying men, he required greater "penetration".
André Malraux perhaps exaggerated when, in 1957, he noted that "For Manet
to paint Clemenceau's portrait, he no choice; he had to dare to be everything
therein, and Clemenceau nothing". Today, some half-century after Malraux's
dictum, our judgment is less dogmatic. The work is a triumph of modern
picture-making not because Manet's presence in it, real as it is, effaces that of
Clemenceau; on the contrary, its greatness lies precisely in its balance.

By his fiftieth year, then, Manet was no longer a *peintre maudit*. The critical
brickbats and the insults of the public had ceased. He was, moreover, a Chevalier
de la Légion d'Honneur, just as his father, the magistrate, had been. But now,
from the height of his talent, illness brought him low. His left leg became gan-
grenous and was amputated, and he died a long and agonizing death. It was, said
Berthe Morisot, "appalling", and she understood him better than anyone. "This is
death in one of its most awful aspects," she told Edma: "A whole span of youth
and work collapsing". He continued painting as long as he was physically able.
Retreating to Rueil, Manet spent his last summer almost entirely immobilised by
locomotor ataxia. There he set himself up under the shade of an acacia to paint
his last landscape, *House at Rueil* (p. 91), his touch lighter and more vibrant than
ever. Not a trace of sky; he remained to the last the city-dweller suffocated by this
walled garden in the Île-de-France where his illness had moored him, living, as
he put it in a letter to Méry Laurent, a life of "penitence". Before he was confined
to his bed, he was still painting the flowers that he was sent and brought by
visitors – the state of his health was no secret. And shortly before his death, he
contrived to finish (like Ingres painting his *Turkish Bath* (1863) in the last years of
his life) what is surely his greatest masterpiece, his *Las Meninas*, his artistic
testament: *Bar at the Folies-Bergère* (pp. 88/89). Indeed, the paintings by Ingres
and Manet have in common their introduction of bold distortions that were to
influence all of modern painting. The barmaid is the most beautiful of the many
objects set before the spectator, but behind her everything seems unreal,
reflections in a mirror of falsehood. Is this a *vanitas*? It is as if Manet were saying:
"Everything is mere appearance, the pleasures of a passing hour, a midsummer
night's dream. Only painting, the reflection of a reflection – but the reflection,
too, of eternity – can record some of the glitter of this mirage …" What a tragic
destiny was his, that of a dandy to whom all the prerequisites of happiness had
been given. Like Poussin, who, feeling the brush tremble in his hand, was forced
to leave his *Apollo and Daphne* (1664) unfinished, Manet might have spoken
Themistocles' words: "Man finishes and departs when he is at his most capable,
or when ready at last to do well".

PAGE 91:
House at Rueil (detail), 1882
Oil on canvas, 78 x 92 cm
Berlin, Staatliche Museen Preussischer
Kulturbesitz, Nationalgalerie

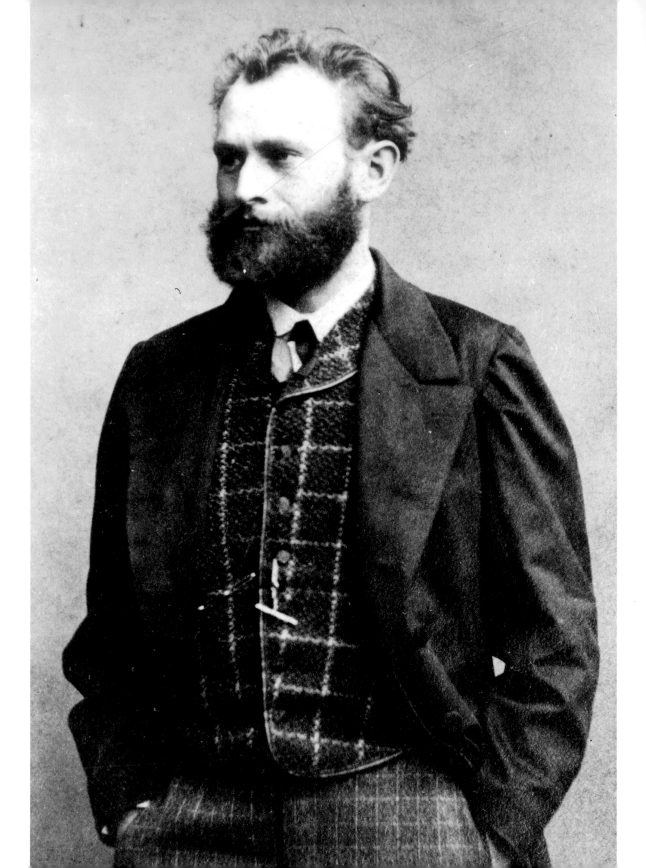

Ed. Manet

1832–1883

Henri Fantin-Latour: Drawing after his portrait of Manet, 1867
Chicago (IL), The Art Institute of Chicago

PAGE 92:
Manet photographed by Carjat, c. 1867

1832 Édouard Manet born in Paris, at 5 rue des Petits-Augustins (now rue Bonaparte), eldest son of Auguste Manet (1797–1862), a high-ranking civil servant in the Ministère de la Justice, and Eugénie-Désirée Fournier (1811–1895), the daughter of a French diplomat posted to Stockholm.

1833 Birth of his brother Eugène (d. 1892).

1835 Birth of his brother Gustave (d. 1884).

1838 Primary education at Abbé Poiloup's Institut in Vaugirard, which he dislikes.

1841 Secondary education at the Collège Rollin, where he meets Antonin Proust (1832–1905), a lifelong friend whose memoirs shed much light on Manet. The two friends often visit the Louvre together, under the guidance of Manet's maternal uncle, Édouard Fournier, who encourages his nephew's talent for drawing.

1848 Report from Collège Rollin describes Manet's work as "wholly inadequate". Leaves the Collège Rollin intending to enter the École Navale, but fails the entrance exam. Embarks for Rio de Janeiro aboard the traineeship *Le Havre et Gaudeloupe*. During the trip, draws caricatures of the officers and commandant.

1849 On his return to Le Havre, again fails the entrance exam for the École Navale; his parents reluctantly agree to his attempting a career in art. Meets Suzanne Leenhoff (1830–1906), a young Dutch woman who gives piano lessons to Édouard and his brothers.

1850 Enrols as student on the register of copyists working in the Louvre, and, with Proust, enters the rue Laval studio of the academic painter Thomas Couture (1825–1879). Despite many arguments – "I don't know what I'm doing here" – he remains for six years.

1851 With Antonin Proust, witnesses the bloody *coup d'état* of Napoleon III

and sketches the dead in the streets. Both arrested during skirmishes and detained for a few nights.

1852 Birth of Léon-Édouard Koëlla, known as Leenhoff (d. 1927), Suzanne Leenhof's illegitimate son, whom Manet is thought to have fathered. Travels to Holland. Copies Boucher's *Diana at Her Bath* in the Louvre (p. 11).

1853 Leaves for Italy with his brother Eugène. Copies old masters, in particular Titian's *Venus of Urbino*, which he later uses as a template for *Olympia*, and Lippi's *Head of a Young Man*, both in the Uffizi.

1857 Meets Fantin-Latour studying Venetian paintings at the Louvre, and, on Delacroix's recommendation, copies Rubens' *Portrait of Hélène Fourment and her Children*.

1859 His *Absinthe Drinker*, in the style of Velázquez, is refused by the Salon, despite Delacroix's favourable judgment.

1861 Exhibits the *Portrait of Monsieur et Madame Auguste Manet* (p. 9) and *The Spanish Singer* (p. 7) at the Salon; the latter receives a *mention honorable*.

1862 Meets Victorine Meurent (p. 15) who becomes his mistress and favourite model.

1863 Exhibits 14 pictures at the Galerie Martinet, including *Music in the Tuileries* (pp. 18/19), *Lola de Valence* (p. 14), *Spanish Ballet* (p. 16). Napoleon III, finding the Salon jury excessively severe, demands the creation of a Salon des Refusés; there Manet exhibits *Le Déjeuner sur l'herbe* (pp. 24/25) and *Mlle V … in the*

Edgar Degas: *Manet, Seated*, c. 1864
New York, The Metropolitan Museum of Art,
Rogers Fund

Costume of an Espada (p. 6). With Baudelaire, attends Delacroix's funeral. Marries Suzanne Leenhoff in Holland. Baudelaire writes to Carjat: "But he has some excuse: it seems his wife is very beautiful, very good-natured, and a very great musician. So many virtues in a single person, it's monstrous, don't you think?"

1864 Poses for Fantin-Latour's *Homage to Delacroix*, which is exhibited at the Salon. Witnesses the combat off Cherbourg of two American ships, the *Kearsarge* and the *Alabama*, and makes a picture of this "news event" (p. 31).

1865 Exhibits *Olympia* (pp. 20–23) and *Jesus Mocked by the Soldiers* at the Salon. Depressed by public and critical reaction, Manet leaves for Spain. Survives cholera during the epidemic.

1867 Organises a solo exhibition featuring 50 pictures in a specially built pavilion, paid for by Mme Manet's mother, near the Pont de l'Alma, just outside the Exposition Universelle. Courbet does the same. The Emperor Maximilian is executed in Mexico. Manet attends Baudelaire's funeral.

1868 Paints a *Portrait of Zola* (p. 48–49) in gratitude for services rendered, which he sends to the Salon

with *Young Lady in 1866*. Sees Berthe and Edma Morisot copying in the Louvre, and is introduced to them by Fantin-Latour. Advises Berthe on her painting; she models for *The Balcony* (pp. 46–47).

1869 *The Execution of the Emperor Maximilian* (pp. 40/41) is refused by the Salon, and the lithograph banned. The printer at first refuses to return the stone, wanting, indeed, to efface it. Manet to Zola: "I thought only publication, not printing, could be prevented; at all events, it's a compliment to the work". By contrast, the Salon accepts *The Balcony* and *Lunch in the Studio*. Berthe Morisot writes to her sister: "Poor Manet is sad. As usual, his exhibition is not much appreciated by the public; he never ceases to be surprised by this …". Manet takes on Eva Gonzalès as his pupil; Berthe Morisot resents his obvious favouritism.

1871 Manet informs his family of the end of the Siege of Paris, and describes the pitiful state of the Parisians. He writes: "I long to embrace you all. I have just this instant learned that poor Bazille was killed at Beaune-la-Roland on November 28".

1872 Durand-Ruel buys 24 paintings from Manet and exhibits 14 at the Society of French Artists in London. The Café Nouvelle-Athènes, place Pigalle,

replaces the Guerbois as a meeting-place for Manet's friends: Degas, Monet, Renoir, Pissarro, and others. With his brother-in-law, Ferdinand Leenhoff, visits the recently-opened Frans Hals Museum at Haarlem, and the Rijksmuseum in Amsterdam. Moves to 4 rue Saint-Pétersbourg, where his first-floor windows offer a prospect of the construction of rue Mosnier.

1873 *Le Bon Bock* (p. 55) has some success at the Salon, where it is shown alongside *Repose* (p. 53). Albert Wolff remarks that Manet has "watered his beer". Alfred Stevens, referring to the influence of Hals, alienates Manet by his witty retort: "Water? It is the purest Haarlem beer". Meets Mallarmé. Sells five paintings to Faure, the famous baritone.

1874 The Salon accepts *The Railroad* (pp. 58/59) but refuses *The Swallows* (p. 61). Mallarmé publishes his article "Le Jury de Peinture pour 1874 et M. Manet" in *La Renaissance artistique et littéraire*. First Impressionist exhibition, held in Nadar's studio, boulevard des Capucines. Manet refuses to take part. Berthe Morisot makes a "marriage of convenience" with Eugène Manet.

1875 Manet illustrates Mallarmé's French translation of Edgar Allan Poe's "The Raven" (pp. 70–71). At the Salon, exhibits a veritable manifesto of Impressionism: *Argentueil* (p. 62). Travels to Venice with his wife and Tissot.

1876 To please Mallarmé, illustrates his poem "L'Après-midi d'un faune" with woodcuts (pp. 94–95). Opens his studio to the public to present pictures of his refused by the Salon. Among the many visitors is Méry Laurent, his future muse and model.

1877 Overtly supports his Impressionist friends during the third Impressionist exhibition, though he still refuses to take part, preferring to try and "break into" the Salon.

1880 The singer Émile Ambre, an admirer, takes Manet's *Execution of the Emperor Maximilian* (pp. 40/41) with her to the United States and exhibits it in New York and Boston. At the Salon, Manet exhibits the *Portrait of Monsieur Antonin Proust* and *Chez le père Lathuille* (p. 80), *The Plum* (p. 74) and *Corner of a Café-Concert* (p. 78). Manet's health is declining. Dr Siredly prescribes hydrotherapy and a stay in the countryside.

1881 Antonin Proust is appointed Ministre des Beaux-Arts, and hastens to make Manet a Chevalier de la Légion d'honneur.

1882 Manet's health worsens. He exhibits *Bar at the Folies-Bergère* (pp. 88/89), his health having made its completion an ordeal.

1883 Again exhibits *Corner of a Café-Concert* (p. 78), this time at the Lyon Salon des Beaux-Arts. 20 April: his left leg is amputated. He dies on 30 April and is buried at the Passy cemetery on 3 May. According to *Le Figaro*, the pall-bearers were Antonin Proust, Émile Zola, Philippe Burty, Alfred Stevens, Théodore Duret and Claude Monet. Degas, leaving the cemetery, reflects: "He was greater than we thought …".

The publisher would like to thank the museums and archives for giving permission to reproduce the works in this book. Unless stated otherwise, the copyright for the illustrated works is owned by the collections and institutions listed in the picture captions, or by the archives of the publishing house.

The Walters Art Gallery, Baltimore: 75; AKG-images, Berlin, Erich Lessing: 44; Bildarchiv Preussischer Kulturbesitz, Berlin: 73, 81, 91; Museum of Fine Arts, Boston, © 2002 photograph: 15; The Art Institute of Chicago, Chicago, © photographs: 28, 29, 37, 52, 93; Ordupgaard, Copenhague: 83; Musée des Beaux-Arts, Dijon: 87; Hill-Stead Museum, Farmington: 33; Kimbell Art Museum, Fort Worth: 85; Courtauld Institute Gallery, London: 88/89; National Gallery Picture Library, London: 18/19, 45, 78; Fundación Coleccíon Thyssen-Bornemisza, Madrid: 84; Städtische Kunsthalle, Mannheim: 40/41; Yale University Art Gallery, New Haven: 13; Metropolitan Museum of Art, New York, © photographs: 6, 7, 34, 35, 39, 64, 66, 94; Solomon R. Guggenheim Foundation, New York, © photograph: 72; Nasjonalgalleriet, Oslo, © photo: J. Lathion: 36; RMN, Paris: 2, 9, 11, 21, 26, 38, 48, 49, 57, 59, 60, 62, 63, 68, 76, 79, 82; Arnaudet: 14; J. G. Berizzi: 20, 22, 23, 51; H. Lewandowski: 24/25, 27, 32, 46, 47, 69, 70; Philadelphia Museum of Art, Philadelphia, © photographs: 30, 31, 55; Princeton University Art Museum, Princeton: 8; Museum of Art, Rhode Island School of Design, Providence: 53; National Gallery of Art, Washington (D.C.), © Board of Trustees: 17, 58/59, 66, 74; The Philips Collection, Washington (D.C.): 6; Artothek, Weilheim: 50, 65; Alfred Schiller: 12; Fondation Collection E. G. Bührle, Zurich: 54, 61.

AT THE TOP:
Dragonfly, 1874
Etching for "Le Fleuve" by Charles Cros

LEFT:
Cat under the Chair, c. 1869
Etching
Paris, Bibliothèque Nationale